CHESTER REFLECTIONS

Paul Hurley

AMBERLEY

First published 2020

Amberley Publishing
The Hill, Stroud, Gloucestershire, GL5 4EP
www.amberley-books.com

Copyright © Paul Hurley, 2020

The right of Paul Hurley to be identified as the Author
of this work has been asserted in accordance with the
Copyrights, Designs and Patents Act 1988.

ISBN 978 1 3981 0428 0 (print)
ISBN 978 1 3981 0429 7 (ebook)

British Library Cataloguing in Publication Data.
A catalogue record for this book is available from the
British Library.

Typesetting by Aura Technology and Software
Services, India. Printed in Great Britain.

Introduction

Chester is well known as a Roman city; it was called Deva Victrix around 2,000 years ago. After the Romans left the area towards the end of the fourth century, it was left to rot for many years, until the daughter of King Alfred of Wessex repaired, rebuilt and fortified it.

Her title 'Aethelflaeda, Lady of the Mercians', was well deserved. As well as ruling Mercia, she led her troops into battle against the marauding Vikings. Around this time Chester became the county town, giving birth to the County Palatine of Chester. It is one of the jewels in Britain's crown and attracts tourists from around the world. The beautiful black and white buildings are mainly from the late nineteenth/early twentieth centuries and were designed by some of the best architects of their generation, one of whom, John Douglas, was described by architectural historian Nikolaus Pevsner as 'the very best Cheshire architect'. This ancient walled city was once one of the most important Roman fortress towns in Great Britain. It stands astride the mighty River Dee, with its castle facing the Welsh border from whence, in days of yore, the invaders would come. Little of the original castle remains; it served the city and held back the Welsh hordes – well, most of them anyway! During the Civil War Chester's walls provided the viewing platform for the king's observation of the Battle of Rowton Heath in which his troops were decisively beaten.

One of Prince Charles' titles is Earl of Chester because down the ages Chester has been a very important city – once called Deva by the Romans who settled there and fortified it, to the battles with the Welsh who attacked it from across the border. It is the only remaining walled city in which the walls are intact and make a very pleasant walk for the many tourists who seek its antiquity. The same can be found on the ancient Rows, shops on two levels dating from, in some cases, as far back as the eleventh century. Sailing ships once came up from the River Mersey to moor on what is now the famous Roodee. The oldest racecourse in Britain, racehorses have replaced ships at this popular destination.

But things had to change to allow for modern traffic, so in the 1960s the great and good of Chester decided that whatever the ordinary Cestrian thought, the city was to be dragged into the twentieth century. To do this, Chester needed opening up to traffic, to widen the narrow ancient streets and demolish some beautiful Georgian buildings, and perhaps a few not so beautiful! The city walls, which had survived centuries of hostile invaders, could not beat the planners. So eventually, the walls were breached; the internal combustion engine was here to stay and must be given priority. An outer and inner ring road was to be built, and old Chester was to be altered. Fortunately, the attractive heart of the city was, in the main, saved for posterity and the enjoyment of the many visitors and residents.

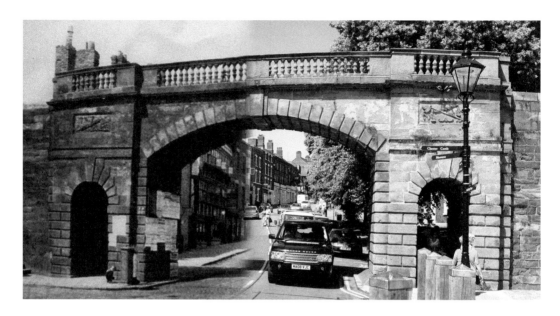

Bridgegate, 1900 and 2010

The Bridgegate in Lower Bridge Street was once the main route from the city over the Old Dee Bridge and through it, people would pass on the way to or from north Wales. In the twelfth century, the Chester walls were extended with a wall alongside the River Dee, and it was within this wall in the early 1100s that the original Bridgegate was incorporated. Built into it was the office for the serjeant of the gate. The gate was rebuilt a few times over the years. In the fifteenth century, the bridge was formed of a tower at each end. The present gate was built in 1782 to replace a medieval gate, and the architect of this one was John Turner. It is a Grade I listed building. The previous bridge, built in 1600, had a tower, John Tyrer's Water Tower, containing machinery to lift water from the Dee for the city. It was named after its builder. In the siege of Chester in 1644–45, it was destroyed. Notice the ornate gas lamp that sits on the top.

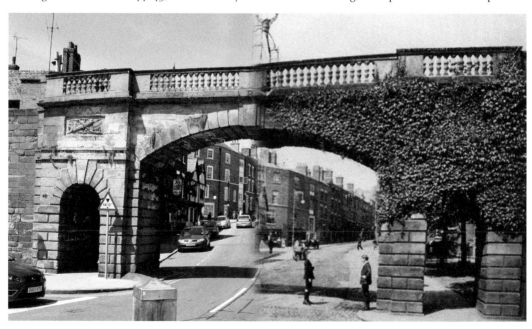

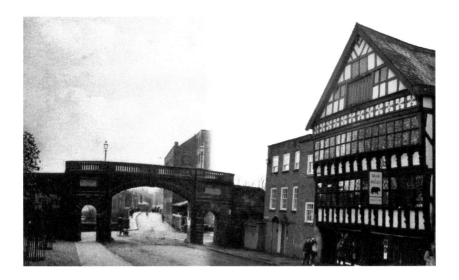

A Look down Bridge Street

Now showing the old Bear and Billet, a pub that has a chequered history lately but still retains the ambience of old. It was built in 1664, and this date is prominently shown on the front elevation. It is one of the last wooden buildings built in the city, and it was built as the town house for the Earl of Shrewsbury who was at the time one of the Serjeants of the Bridgegate. This entitled him to collect tolls from people passing through the nearby Bridgegate. It was at one time known as The Bridgegate Tavern. It is recorded as a Grade I listed building and has been described as 'the finest 17th-century timber-framed town house in Chester and one of the last of the great timber-framed town houses in England'. Its name is taken from the heraldic device on the arms of the Earl of Shrewsbury that consists of a bear tied to a billet or stake. John Lennon's maternal grandmother, Annie Jane Milward, was born at the pub in 1873 and lived there until she was in her twenties. The Bear and Billet's Grade I listing did not stop it being refurbished in 1999 and renamed Bensons at the Billet. The locals were not happy about this, and a year later it reverted to The Bear and Billet and is still serving the public under its ancient name. Like other pubs in this street, walking through the door is like walking back to a time of dark wood, old-fashioned glass windows and the ambience of another era.

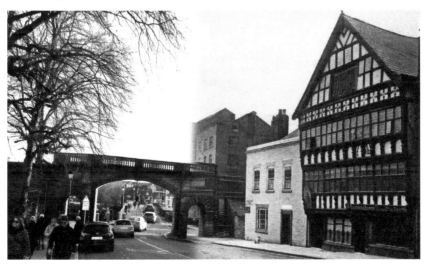

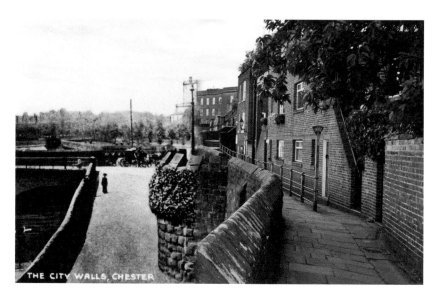

City Walls at Bridgegate, 1912 and 2010

This image shows a section of the city walls that circle the city; in this case, the length that crosses over the Bridgegate and Lower Bridge Street at the start of the Old Dee Bridge. The steps can be seen ahead. It was the Romans who built the walls as a defensive structure to protect the city, known then as Deva Victrix when they occupied the city around AD 70 or 80. Originally the walls were made of wood, and 100 years later they were built using sandstone, a job that took 100 years to complete. Around AD 300 to 400, the Romans abandoned Chester and it became run-down and occupied by Christians known as Romano-British, then the Danes for a short time. In 902 the Saxon Aethelflaed, daughter of Alfred the Great and wife of Æthelred, Lord of the Mercians, arrived and rebuilt the city, renewing and repairing the walls in time for a joint raid by Norsemen and Vikings. On her husband's death, she became Lady of the Mercians and Queen Æthelflæd of Mercia, a brave and intelligent leader who in 907 refounded Chester as a burgh. After the Norman Conquest of 1066, the walls were extended to form a complete circuit of the city.

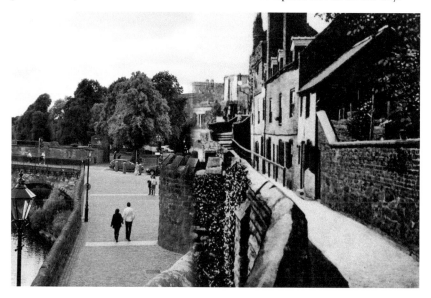

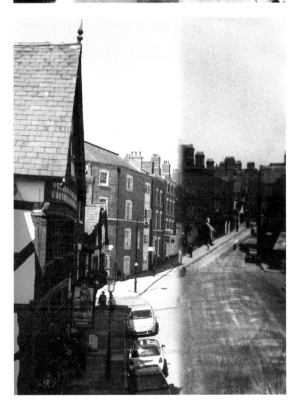

Lower Bridge Street, 1920s and 2010
Now we peruse a photograph taken from the walls crossing the Bridgegate and looking down into Lower Bridge Street. The Bear and Billet public house is in the foreground, one of Chester's oldest pubs. Dating from 1664, it was once the home of the Earls of Shrewsbury.

The wheel of the cart has been turned into the pavement to save the full weight from pushing the horse down the hill as it rests. At one time Dee Mills was at this end of the Bear and Billet.

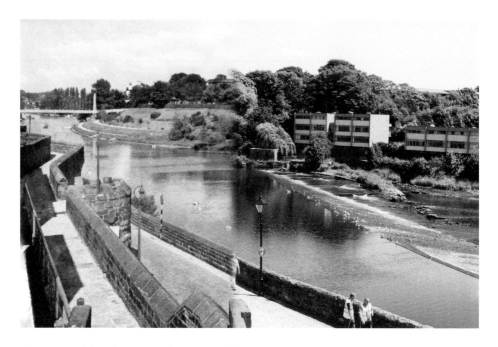

River Dee with Tobacco Works, 1948 and 2010

The old photograph here shows the very attractive Nichols Tobacco and Snuff Mills in 1948. Many local people were employed here making all forms of tobacco products. The firm was established in 1780. It was closed and was unoccupied in June 1950 and remained empty. In the 1960s, there was a fire and the building was demolished as a result. A short while later, in an era not renowned for architectural excellence, planning permission was granted for the building of the extremely unattractive Salmon's Leap blocks of flats, as seen in the modern photograph. What would the brilliant architect John Douglas have thought of them? And what would the many tourists think as they look across the River Dee?

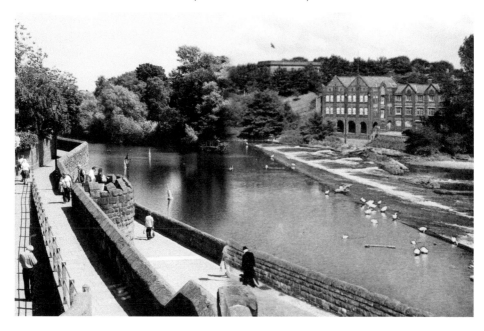

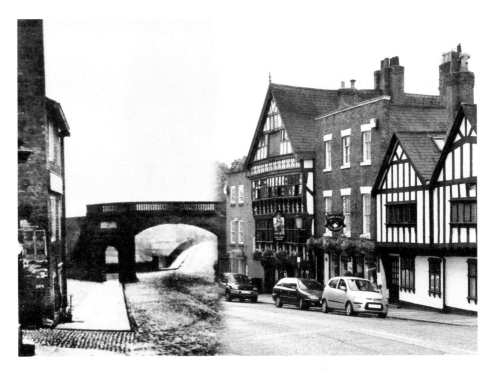

Lower Bridge Street, 1860 and 2010

We look down again now towards Bridgegate in what is another of the very early photographs. We see again the Bear and Billet public house, originally called The Lower White Bear. Nearer the camera is Ye Olde Edgar, dating from 1570 and one of the best examples of a late Tudor building. It is now two dwellings, and the inn name survives on the side. Dee Mills can be seen beyond the gate.

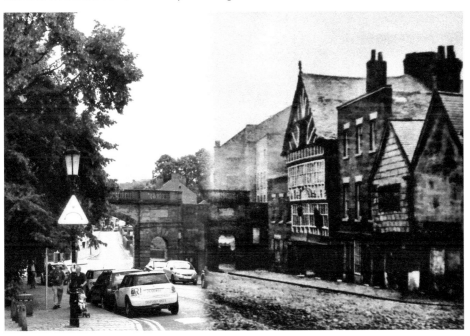

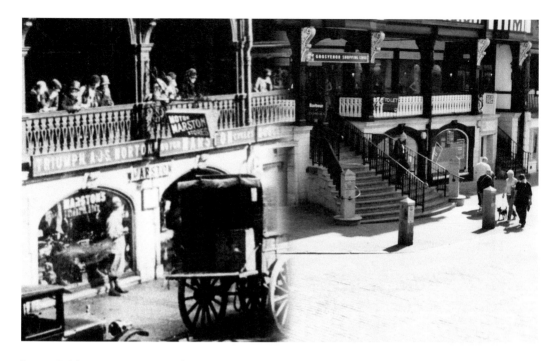

Lower Bridge Street, 1920s and 2009

A photograph simply oozing period charm from the 1920s: horse-drawn carriages are still in use, but motor cars are starting to predominate. The shop beneath the Row is catering for this upsurge in mechanically propelled vehicles and deals in motorcycles. The company is Marston's, and they offer for sale Douglas, Triumph, AJS and Norton brands. Oh, those memorable days when the British motorcycle industry was the best in the world, but at least we still have Triumph and Norton.

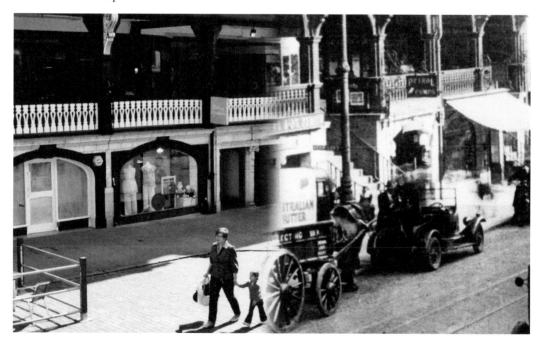

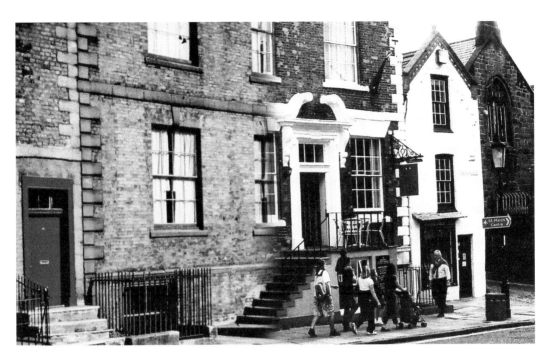

Lower Bridge Street, 1956 and 2009

The year is 1956, and everything still looks very much the same due to careful restoration. On the right is St Olav's Church. It is believed there was once a Scandinavian community in this area – hence the name. The church was founded in the eleventh century, and this building dates from 1611. In 1841 the parish was amalgamated with St Michael's, and in 1849 the church was restored by Thomas Harrison. It was declared redundant in October 1972 and has had several uses since then. The building is Grade II listed.

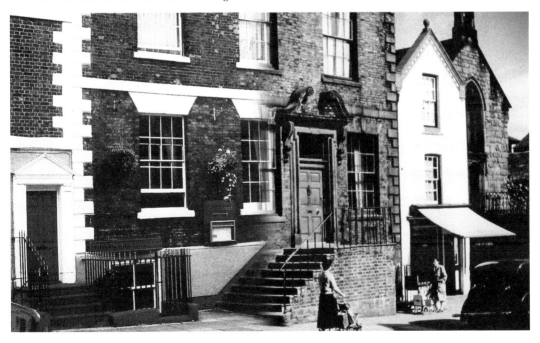

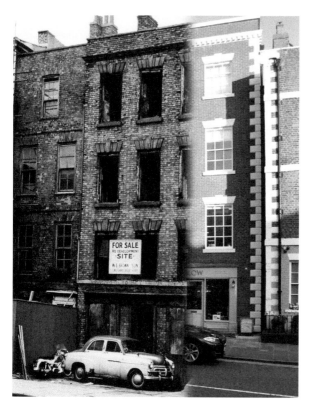

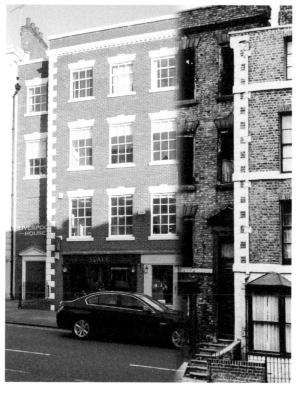

Liverpool House, Lower Bridge Street, 1960 and 2010
This former lodging house had a sign across the front which read, 'Clean beds and good kitchen'.
In the photograph from 1960 a Vauxhall Velox saloon and an Ariel Leader motorbike adorn the hard standing. The building is more evidence of sympathetic alteration and upgrading. The modern photo was taken in 2010, and the two shops on the ground floor are Suave (gentlemen's grooming) and Blow, a beautician's.

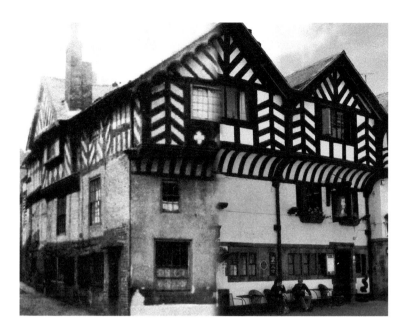

Ye Olde Kings Head

This pub is on the junction of Lower Bridge Street and Castle Street – the street that leads up to the castle. It was constructed in 1622 for Peter Clerk, the administrator of Chester Castle. The foundations date back to the early 1200s, and the front elevation can be dated back to the seventeeth century. It first became a pub in 1717. Once it contained a section of the Rows but these were closed during the early eighteenth century. One of these alterations was made for Randle Holme, the Chester historian and first mayor of Chester from 1633 to 1634, and was described at the time as a 'new building'. The building was also restored in 1935 and again during the 1960s. On the sidewall in Castle Street is a unique iron plaque that warns people to 'Commit no Offence'.

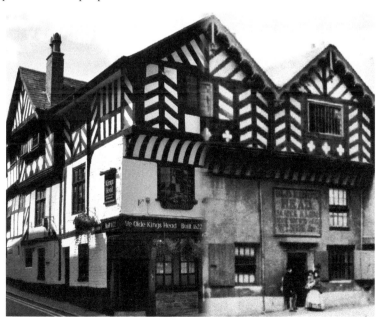

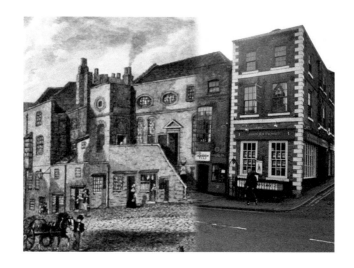

The Brewery Tap

Set back from the road up a short stairway, this popular pub building is an important part of Chester's heritage. Known as Gamul House, the building was once a Jacobean great hall that had been built for the Gamul family and is the only stone-built medieval hall to survive in Chester. This family were wealthy merchants in the city and powerful enough to support their own army. This army was lent to Charles I, who stayed here from 23 to 26 of September 1645. Parts of the present Gamul House date from around the early sixteenth century with the oldest visible areas being the wall and fireplace behind the bar. In those early days, most buildings were built of wood with manure and mud infills. After such fires as the Great Fire of London, local councils started to look at this use of wooden structures. It was after this that the medieval façade of Gamul House was changed for a brick-built one. The raised walkway in the front of The Brewery Tap was once part of the Row and the only bit remaining. Thomas Gamul was the city's recorder, and his father was mayor on four occasions. His son Sir Francis was a staunch Royalist and resided here during the Civil War. He was responsible for the city's defences and the last time that Charles I stayed was the night before the Battle of Rowton Moor or Rowton Heath, and it was from here that he would have made the short walk to the walls of Chester to watch his army lose decisively to the Parliamentarians. Over the years Gamul House became run-down. Chester City Council purchased it and started a full refurbishment in the 1970s. On the fireplace behind the bar is a painting of the arms of the Gamul family.

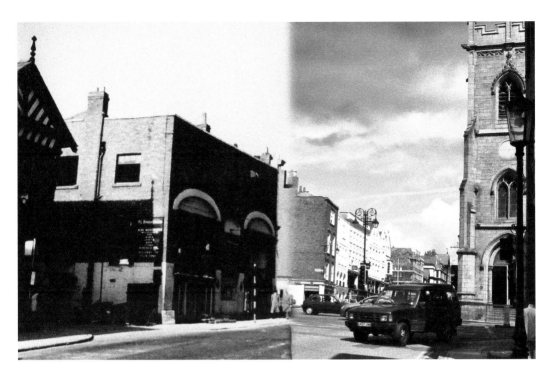

Bridge Street Junction, 1964 and 2010

Looking up Bridge Street with the Falcon pub on the extreme left, the large building beyond the Falcon has gone to make way for the ring road. On the crossroads is the Chester Heritage Centre. This was originally St Michael's Church, which is one of nine medieval churches in Chester. It stands on the southern gateway of the Roman fortress and was completely overhauled between 1849 and 1861. It became Britain's first heritage centre in 1975.

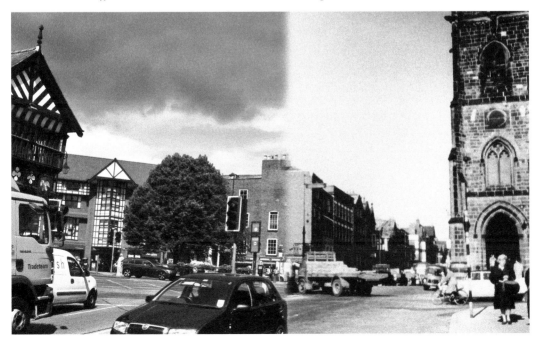

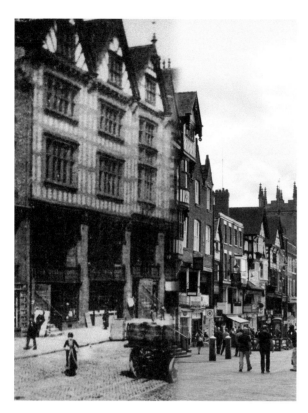

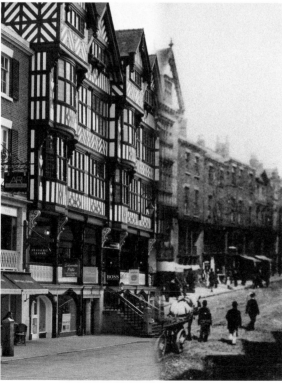

Bridge Street, Site of Feathers Hotel, 1880s and 2010

We now look at the site of the Feathers Hotel after the replacement had been built. This replacement is a beautiful black and white building, but as can be seen from the old photograph, this hasn't always been the case, and some alterations have been carried out to the front elevation. It is a different building but tastefully updated to what we see today.

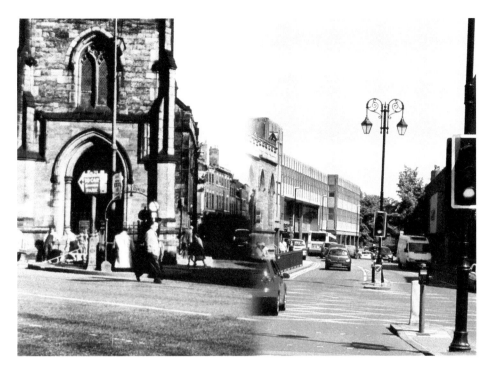

Grosvenor Street into Pepper Street, 1960s and 2010

Seen here is the junction of Grosvenor Street, Bridge Street and Pepper Street in the town centre. In the old photograph, the underground gent's toilet can be seen. Many buildings on both sides of Pepper Street were demolished. This was to make way for this section of the ring road, which was opened in 1966.

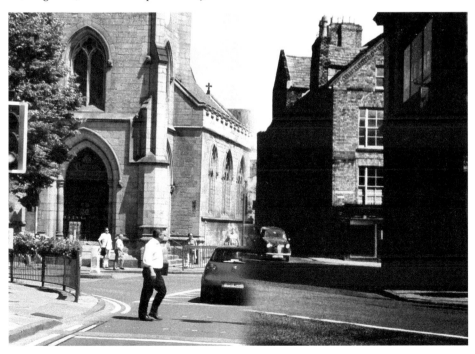

Park Street, 1908 and 2009

Park Street is off Pepper Street and runs parallel with the walls from which these photographs were taken. The row of cottages was built in 1650 and was known as the Nine Houses, although only six have survived. They were restored and modernised in 1968/69 after an objection to their demolition by the residents of Chester.

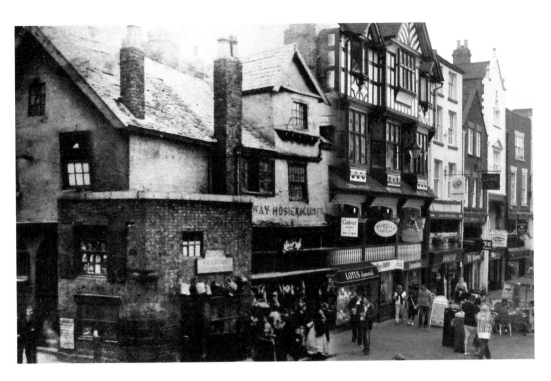

The Cross, 1860 and 2010

This ancient photograph is quite poor, as you would expect it to be. It depicts one of the rarest views of what is known as the Chester Cross area and shows a building in a very poor state. By 1888 it had gone and in its place was built the beautiful black and white building shown.

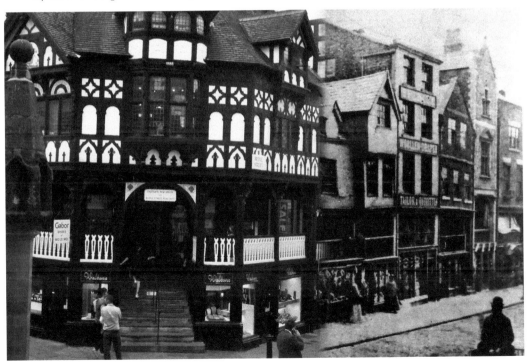

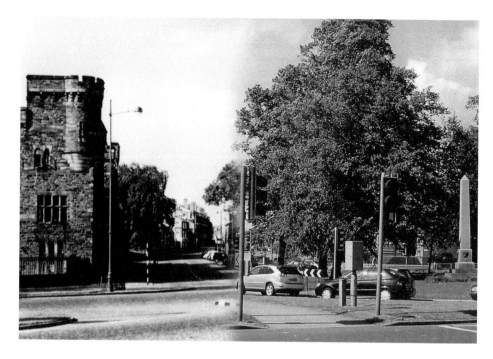

View up Nicholas Street, 1952 and 2010

This photograph looks at the old Militia Building. This was later used as married quarters for the troops based at the castle. I'm told that the living conditions for the soldiers' families were extremely poor. The obelisk was at one time standing in the cemetery of St Bridget's Church which stood here. It commemorates Matthew Henry, who was a Presbyterian minister. As part of the old graveyard, it is in the centre of the Grosvenor roundabout.

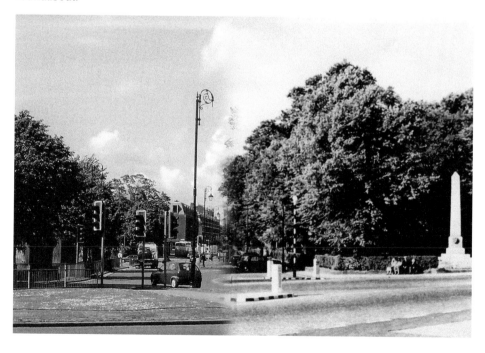

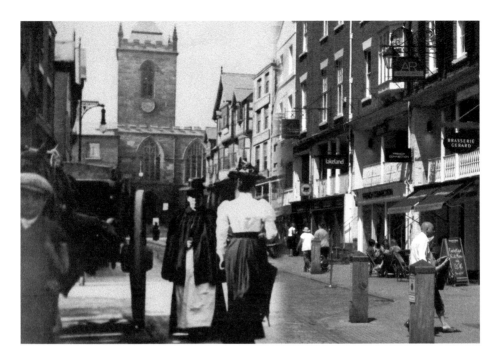

Bridge Street, 1890s and 2010

A view up Bridge Street towards St Peter's Church at The Cross, as we see the ladies in their Victorian finery walking past a heavy horse-drawn cart. Little has changed as far as the buildings are concerned, and the road surface still consists of stone sets, although whether they are original is another matter! The modern photo shows that the street has now been pedestrianised.

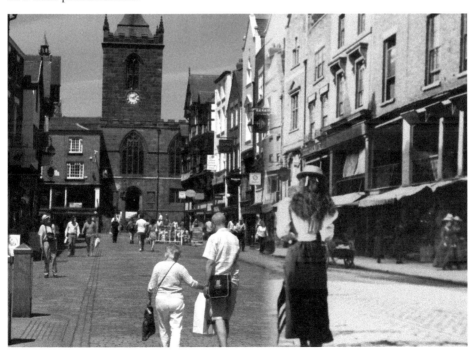

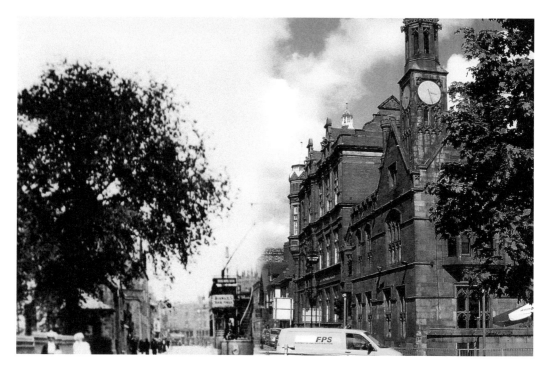

Grosvenor Street, 1906 and 2009

The Saltney tram is passing the former Trustee Savings Bank, which was next to the Grosvenor Museum. The museum was founded in 1885 possibly under the auspices of the Chester Society for Natural Sciences, Literature and the Arts, which had been instituted by Charles Kingsley, Canon of Chester Cathedral from 1871 to 1873. It now has around 100,000 visitors a year.

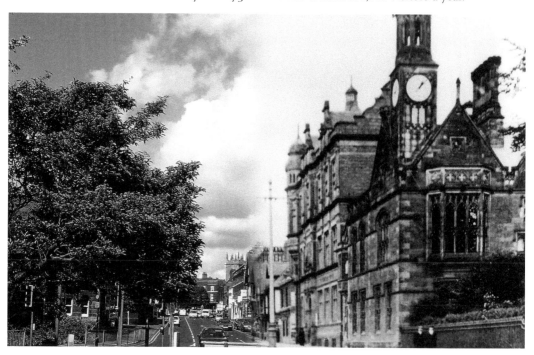

Custom House, Watergate Street, 1905 and 2010

This building, now Ye Olde Custom House Inn, was built originally as a town house in 1637 for Thomas and Anne Weaver; the lane at the side is called Weaver Street after them, and you can still see their initials carved on the front. It obtained its name from the real custom house building across the street when goods brought ashore at the Chester port would be brought up the street to be sold in the city centre and transported onwards. In the 1950s when Wales was 'dry' on a Sunday, this was the only pub in Chester selling Border Ales from Wrexham. On that night it was packed!

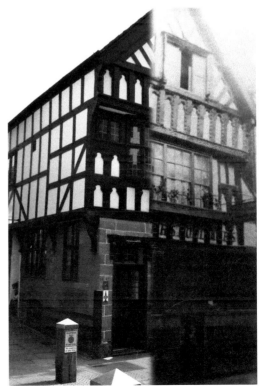

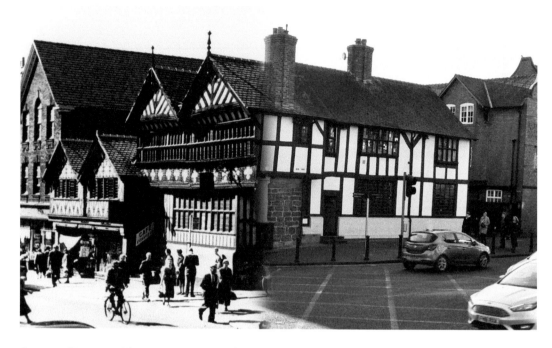

Corner of Lower Bridge Street, 1950s and 2010

This image shows the building that stood next to the old Falcon Inn until road widening swept it away. You can see The Falcon beyond it. The large building was the Old Lamb Stores containing a bar and function room. I have an old image of the old Lamb Inn that was there before it and was truly ancient with the front elevation leaning over Grosvenor Street at such an angle that it eventually tumbled forward into the road.

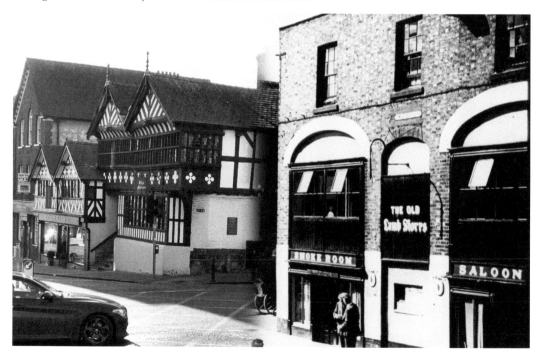

Commonhall Street, 2003 and 2009

Here we see another example of good planning in modern architecture. Commonhall Street went through quite a transformation in 2003 and this shows the result. The striped building at the end of the row gives a perspective on the rebuild.

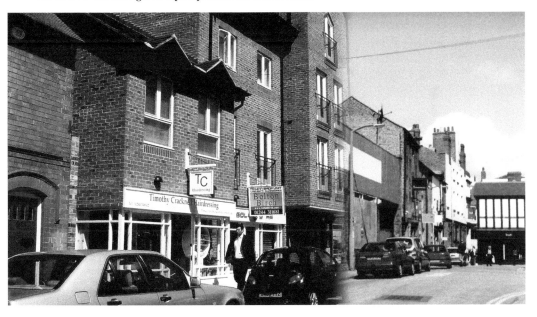

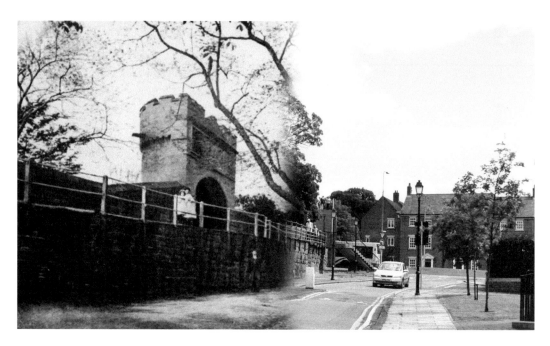

Goblin Tower on the City Walls, 1908 and 2010

This unusual half-tower is situated on the North Wall and was originally called Goblin Tower, a name that can still be seen at the top of it together with its rebuild date of 1894. It also bears the name Pemberton's Parlour after John Pemberton, a rope maker and mayor of Chester in 1730. It has a well-worn sandstone tablet naming the mayors and the men responsible for repairing the wall in days long gone.

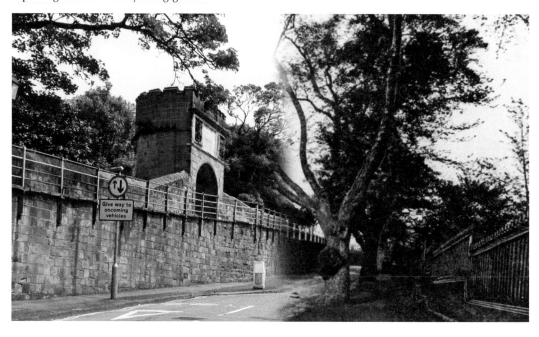

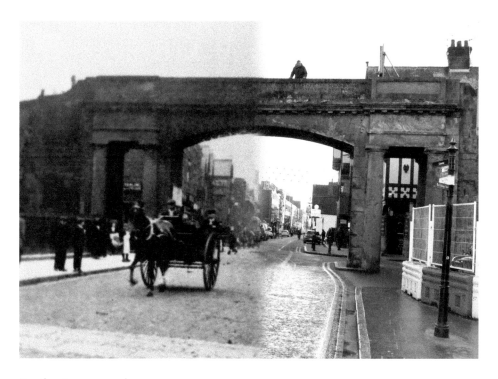

Northgate, 1905 and 2010

The Northgate was rebuilt in 1810 to replace a large gateway which until 1807 housed the city gaol. The new gaol was built on the site of the present Queen's School in 1807 but closed in 1872. The school is by the city walls located through the gate and immediately right.

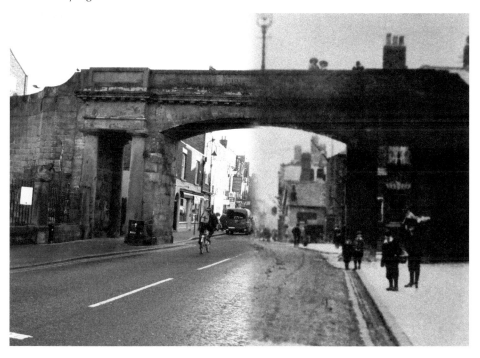

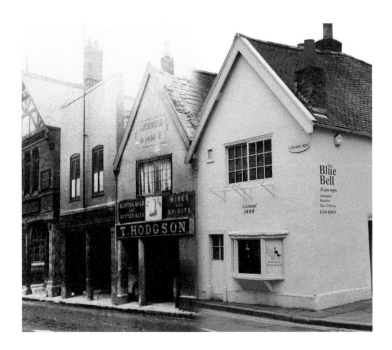

The Blue Bell Inn, 1912 and 2009

The Blue Bell Inn is situated in Northgate Street and is the oldest domestic building to survive. It was built during the mid-fifteenth to sixteenth centuries as two houses; they became a single property in the eighteenth century. For most of its life, the Blue Bell has been an inn, claiming to have received its first licence in 1494. In the 1930s it was threatened by plans to widen Northgate Street and closed as an inn. It opened as an antique shop in 1948 but was very run-down and had to be rescued by the Chester Civic Trust and restored in 1960. It is now a restaurant.

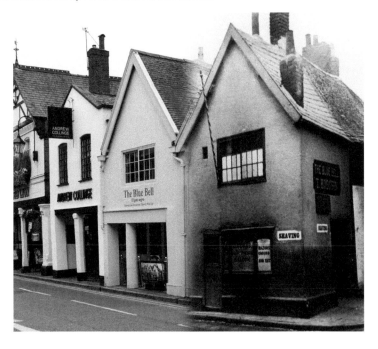

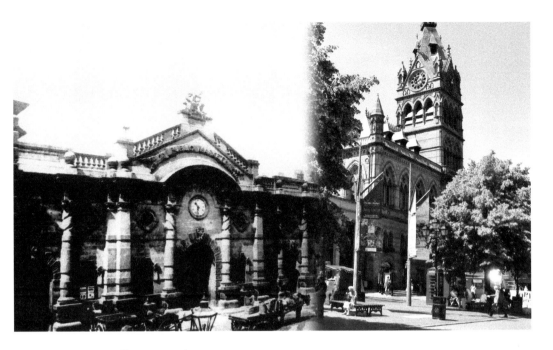

Old Market Hall, 1890s and 2010

This is Town Hall Square in Northgate Street, and the market hall was built in 1863 with an ornate baroque and brutal façade. Sadly it was demolished in 1967 and replaced with a brick box-like frontage, to be seen later in the book. Then in 1995 it was replaced again with a mainly glass and stone frontage. A tree masks this new addition.

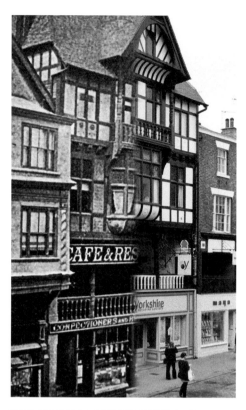

Lower Bridge Street Café Restaurant,
1920 and 2010
This is No. 20 Bridge Street, and in the
photograph from 1920 we see a fine Victorian
black and white building, part of a group
of buildings known as 'The Dutch Houses'.
In 1920 it was a café and confectioner's, later
becoming the Plain Tree Café, then Burger
King and now the Yorkshire Building Society.
The Plain Tree sign still survives in the
modern photo.

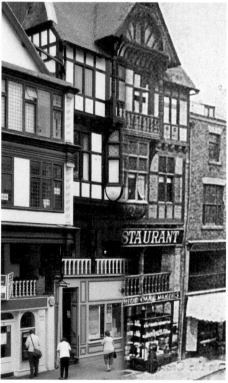

The Pied Bull Hotel, Early 1900s and 2010

The Pied Bull Hotel stands in Northgate Street and is another well-known Chester coaching inn. This is believed to be the longest continually licensed public house in Chester. The Cycle Storage sign is still on the side wall in the modern photograph, and the long sign on the front gives the coaching distances from the pub. The land to build it was given to the nuns of St Mary and dwelling houses were built here in 1267. It has a handmade staircase dating back to 1533 when it was rebuilt and became the home of the Recorder of Chester. Around twenty years later it became an inn called The Bull Inn, reflecting the existence of the cattle market or beast market outside the nearby Northgate. This was later changed to The Pied Bull.

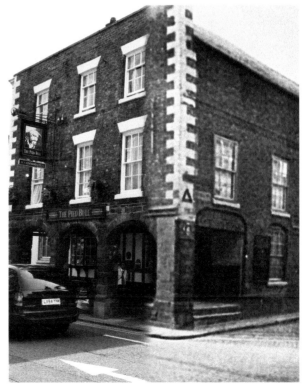

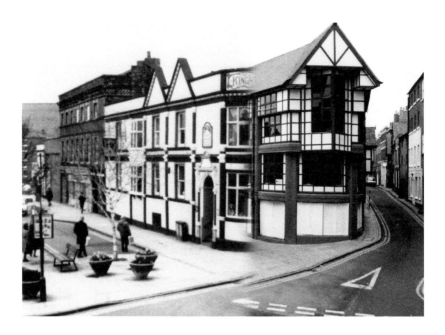

Ye Olde Kings Head

Not to be mistaken for the Queens Head in Lower Bridge Street that is still there, this one has gone and been replaced by the modern-ish building. The hotel was built in the very early 1800s and remained a popular pub and hotel until 1986, when the powers that be decided to demolish it and build a large mock-Tudor office block in its place. That replacement has been described by various historians as a 'Lego' building – see what you think with this selection of before and after photographs of the area and the hotel. My Pigot's directory for 1828 gives the tenant as William Posnett. Enjoy a bit of old Chester that has gone forever with these photographs of Grosvenor Street with the Kings Head on the far right. The date is 1960, and the photograph is filled with period charm.

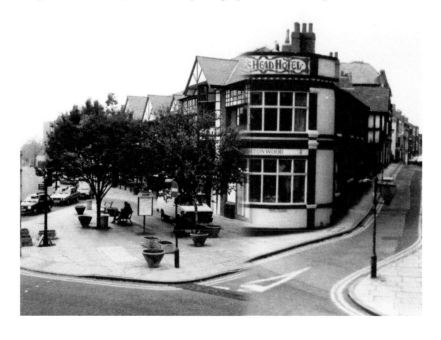

Former Golden Cock, Castle Street, 1965 and 2009
This view taken at the top of Castle Street is of the old 'Golden Cock' hotel. This was later converted into a garage and has now been well restored with a new block of flats alongside. Castle Street can be found off the Grosvenor roundabout.

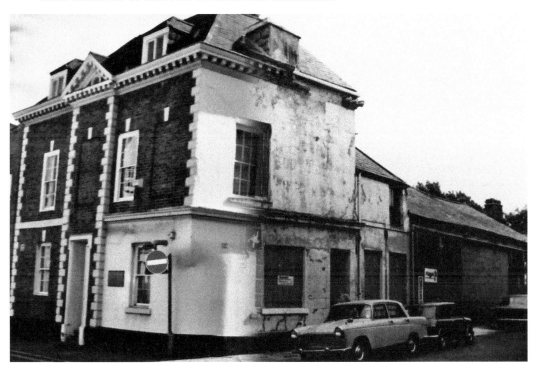

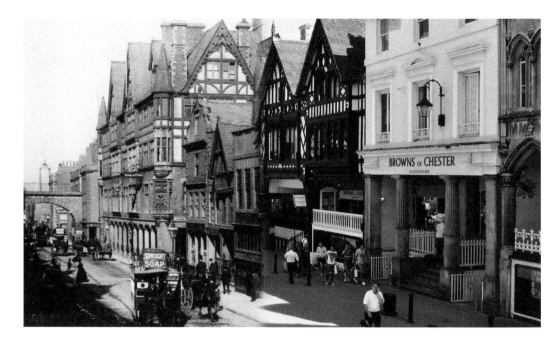

Eastgate Street, 1897 and 2010

Here we have quite a unique photograph as it shows the famous Chester Clock, which straddles the city walls over Eastgate Street. This old photo was taken as the clock was under construction and was to celebrate Queen Victoria's Diamond Jubilee on 27 June 1897. In the photograph, only the frame is there as it awaits the fitting of the clock face.

This photograph is absolutely filled with period charm, showing horse trams and many other forms of horse-drawn transport. There have been some alterations to the buildings but in the main little has changed architecturally.

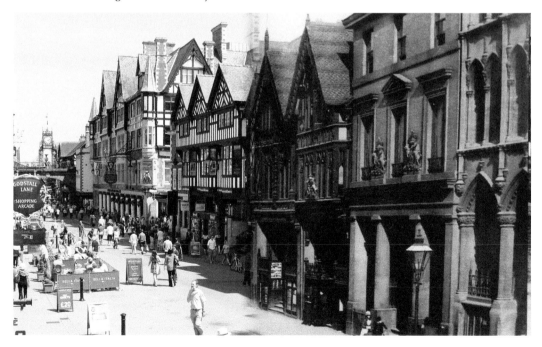

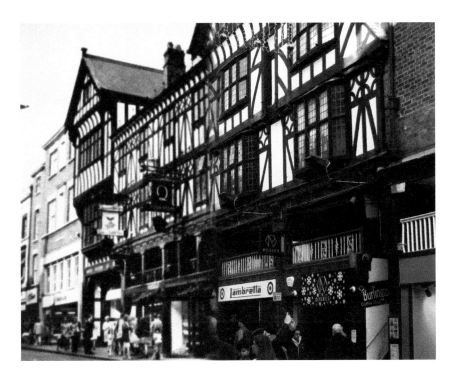

Quaintways, Northgate Street

Here is an iconic Chester nightclub. It was opened in the 1960s by Chester entrepreneur Gordon Vickers as a nightclub and venue for bands – and in those days, did they feature bands! Appearing in the heyday of the 1960s and '70s were bands such as The Wall City Jazz Band, Fleetwood Mac, Uriah Heap, Status Quo and Dire Straits to name but a few. It is still a nightclub going by the name of Rosies – a modern club on three floors.

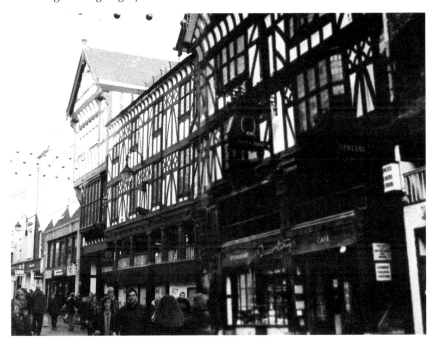

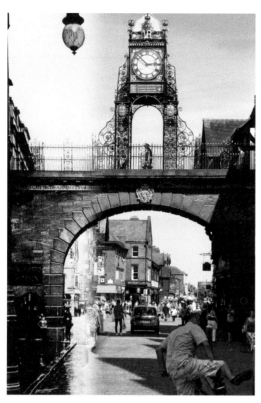

The Clock, 1910 and 2010

A look at the famous clock now with a photograph taken of Eastgate Street away from The Cross. The clock was designed by the Sandiway architect John Douglas to celebrate Queen Victoria's Diamond Jubilee. It was built by the cousin of John Douglas, James Swindley of Handbridge, and the clock itself provided by J. B. Joyce of Whitchurch. Until 1974 it had to be wound by hand every week and is said to be the most photographed clock in the world after Big Ben.

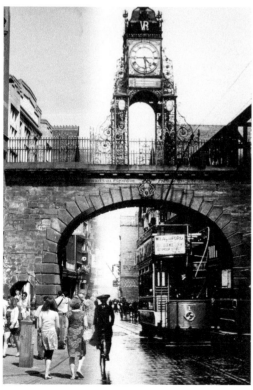

Northgate Brewery

The large Northgate Brewery was founded in 1760 at the Golden Falcon Inn. This inn stood close to the Northgate, and it was first recorded in 1704. For many years it was considered the principal coaching inn of the city but by 1782 it had become a doctor's surgery. A new brewery complex was built on the site in the 1850s, and the Chester Northgate Brewery Co. Ltd was registered in March 1885 as a limited liability. The company acquired Salmon & Co., wine and spirit merchants, Chester, in 1890 and the Kelsterton Brewery Co. Ltd, Kelsterton, Clwyd, in 1899 with ninety-three licensed houses. By 1891 the company owned twenty-one tied houses in Chester and numerous others within a 15-mile radius from the city. It was the only Chester brewery to survive beyond 1914. In its turn, it was acquired by Greenall Whitley & Co. Ltd in 1949 with around 140 tied houses. Brewing ceased in 1969, and it was demolished in 1971.

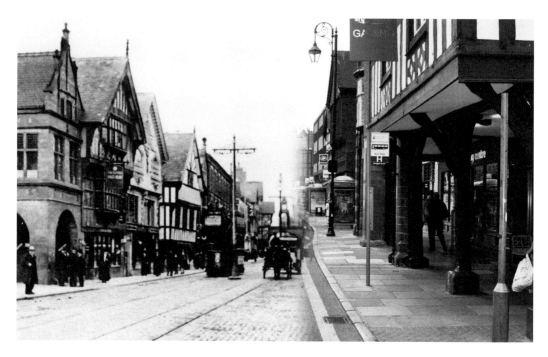

Foregate Street, 1906 and 2010

We now walk down Foregate Street and stop opposite the McDonald's takeaway, looking back towards the clock. In the old photograph we see electric trams and motor buses with a horse and cart ambling down towards the camera. This area has changed quite a bit over the years, and some very nice buildings have gone to make way for the not so nice.

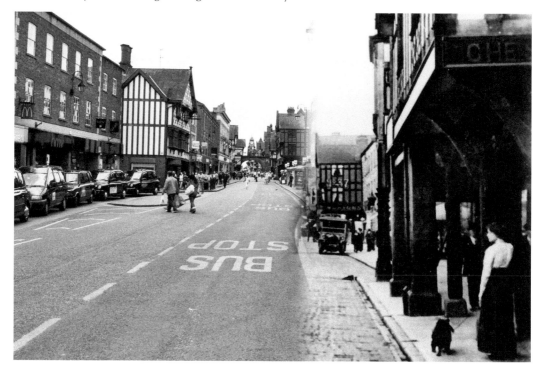

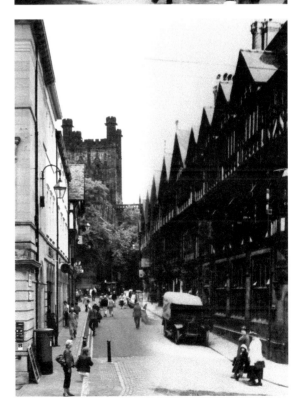

St Werburgh Street, 1920s and 2010
We now take a look up St Werburgh Street towards the cathedral.
This street was widened and the east side redeveloped with the backing of the Duke of Westminster and the designs of architect John Douglas, who I believe owned that side of the road and it was at the Duke's insistence that Black and White was used in the build. A plaque was erected here in 1923 in appreciation of the work done by John Douglas. Here we see an eclectic mix of 1920s traffic and dress.

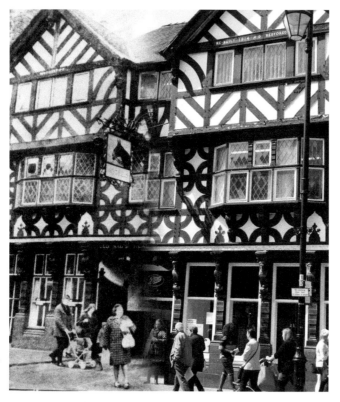

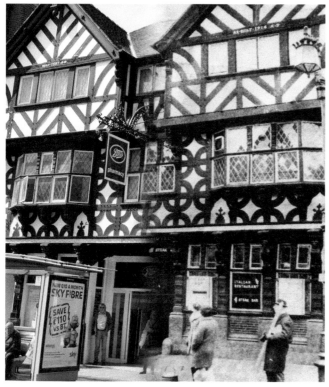

The Olde Nags Head Hotel, now Boots, 2015

Although the building no longer houses a pub, it is still a beautiful black and white building that now houses a branch of Boots. The floor of the old pub has been greatly increased to cover what was an abattoir in Queen Street at the rear. The entry to the rear of the building has also been incorporated into the new shop premises. The earlier Nags Head was built in 1597 as is recorded on the front elevation, but it was completely rebuilt in 1914. In 1980 it was restored again. These dates are also recorded on the front. In 1788 it was owned by Aaron Miller, who went bankrupt. It was sold in the same year and appears to have been purchased by a Mr J. Whalley. By 1828 Mr George William Walker was the landlord. It closed in 1970 and is now retail premises.

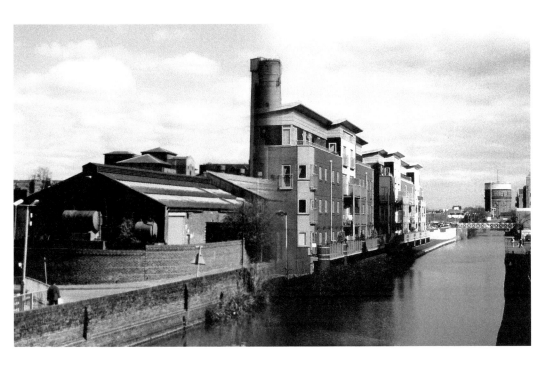

Leadworks and Canal, 2002 and 2009
The tall tower in the centre is the Chester Shot Tower, which is also known as the Boughton Shot Tower. It stood in the Chester Leadworks, which was built by Walkers, Parker & Co. in 1799. The tower is the oldest of three remaining shot towers in the UK and probably the oldest such structure still standing in the world. Molten lead was poured through a pierced copper plate or sieve at the top of the tower, with the droplets forming perfect spheres during the fall. The spherical drops were then cooled in a vat of water at the base. The area has now been redeveloped around it.

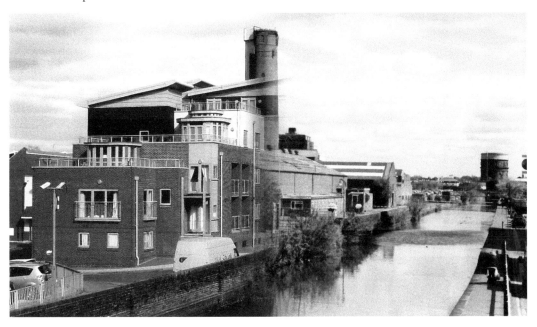

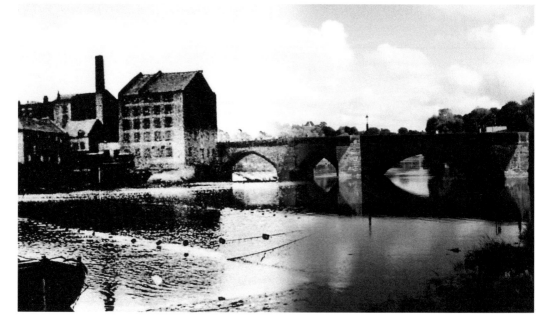

The Old Dee Bridge

The Old Dee Bridge is the oldest in Chester, and the first one is believed to have been built by the Romans in brick with a wooden carriageway. On the arrival of Aethelflaed, there was only a ferry to cross the River Dee. Another bridge was built to replace the ferry, and this was rebuilt and repaired over the years. Legend has it that in 1357 when Edward the Black Prince passed over it on his way to fight the Welsh, half of the bridge was in good condition, but not the other half. He demanded that the bridge be made good in its entirety, or he would sack the city. This was duly done and over the intervening years the bridge was rebuilt and repaired as required. In the old photo, salmon fishers are fishing on the Dee, and the mill at the far end of the bridge can be seen.

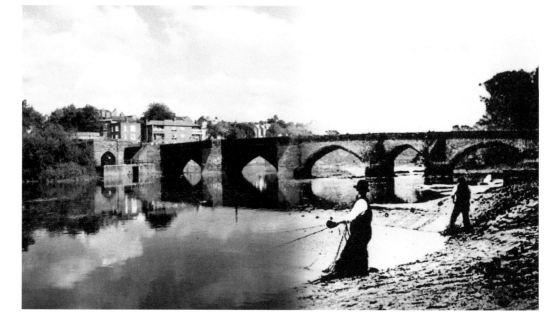

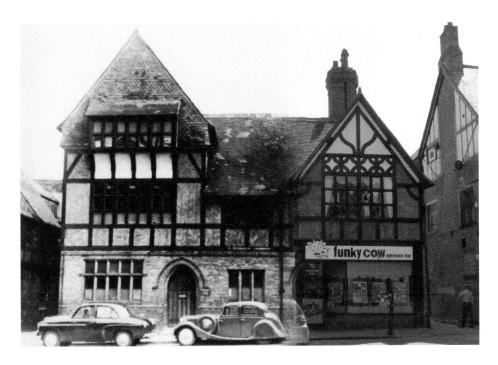

St Werburgh Street, 1955 and 2010
The building here is St Werburgh Chambers, and it stands opposite the cathedral. The openings that can be seen in the 1955 photograph on either side of the building are two of the remaining four medieval lanes within the city. Left is Godstall Lane and right is Leen Lane. The whole character of the building has been lost since its conversion to shop premises.

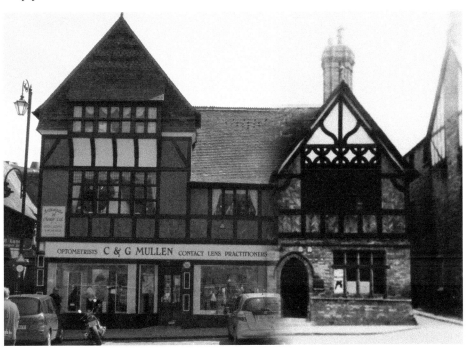

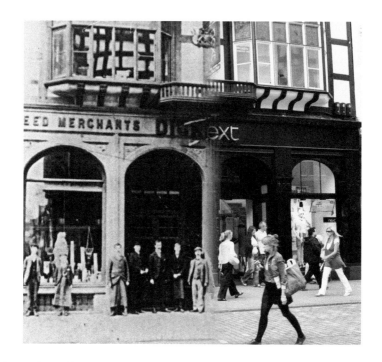

Dickson's Seed Merchants, 1904 and 2010

This building in 1904 was the headquarters of Dickson's Seed Merchants, and their seed nursery was in Dickson Drive, Newton. The entrance on the right under the Corn Exchange sign was also the entrance to Chester's first silent movie cinema called The Picturedrome, opened 8 November 1909 and closed 29 March 1924. It was a Woolworths store for many years and is now a branch of Next.

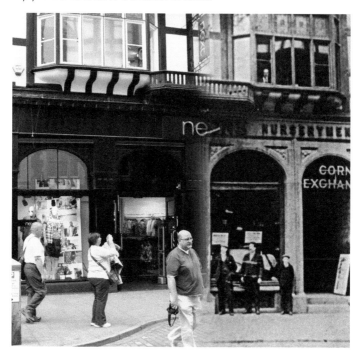

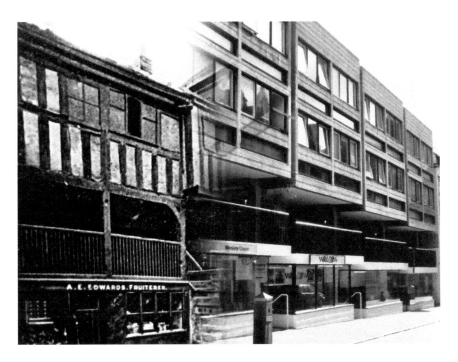

Uncle Tom's Cabin, Watergate Street, 1905 and 2009

This building was known as Uncle Tom's Cabin, as it shows on the front of the old photo, but where that name came from seems to be lost in the mists of time. I suppose it looks a bit like a cabin? The shop at the side was the premises of Amy Elizabeth Edwards, who traded as greengrocers at this premises, No. 55. In the 1950s, the old buildings were demolished, which left an unsightly hole in the row until the concrete eyesore was built a short while later.

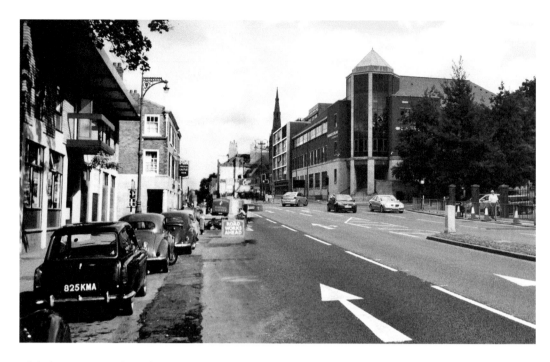

Nicholas Street, 1964 and 2010

Nicholas Street is now part of the ring road and starts at the Grosvenor roundabout. The 1964 photograph was taken as building work was in progress to both widen the street and replace most of the buildings. Still intact however is the former Church of the Holy Trinity, with its spire showing in both photos. No longer used as a church, it is now the Guildhall of the Freemen and Guilds of Chester.

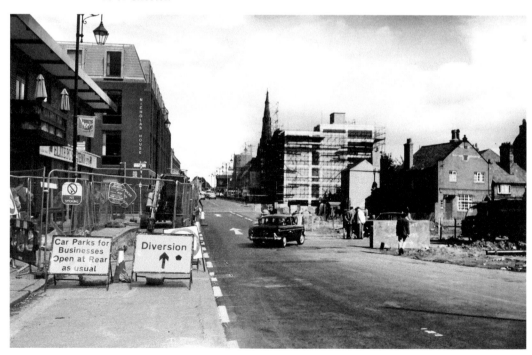

Northgate Street, 1908 and 2010

Aethelflaed built the ancient church at the junction with Eastgate Street and Northgate Street –
St Peter's Church, seen on the left of the photographs. She was the daughter of King Alfred in
AD 907, so it is one of the oldest churches in the county. The policeman in the old photograph
has rather an easy job directing traffic!

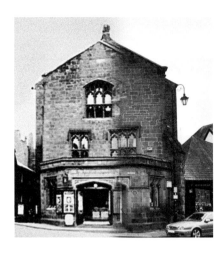

Music Hall Cinema

This ancient building at the junction with Northgate and St Werburgh Streets was once home to the Music Hall Cinema. Abbot Simon of the Abbey of St Werburgh constructed the original building in 1280 as a chapel dedicated to Saint Nicholas. After remaining empty for a time, the old chapel was later used as a wool hall; it had also served as the Common Hall between 1545 and 1698. From 1773 it was called the New Theatre until it was renamed the Theatre Royal in 1777, where appeared such superstars of their day as Sarah Siddons in 1786 and Edmund Kean in 1815. In those days, audiences didn't sit quietly to enjoy a nice play as they do today, but would argue and fight among themselves and throw objects and abuse at the performers if their efforts failed to please. In 1855 the building became the home of the Chester Music Hall, after being redesigned by architect James Harrison. Charles Dickens gave a talk here in 1867 and later described it thus: 'The hall is like a Methodist Chapel in low spirits and with a cold in its head.' Many other famous names gave lectures including the explorer Roald Amundsen, and Winston Churchill, who spoke on the Boer War in 1901. Films were shown occasionally from the early part of the twentieth century. The London Animated Picture Co. ran films here in 1908. Films were screened regularly from 1915 when it was known as Music Hall Pictures and was an early cinema. In April 1961 the Music Hall closed; the final offering was *Never on Sunday*. Since the closure, the building has had many uses, including a branch of Lipton's – Chester's first supermarket within the city walls – Foster's gent's outfitters in 1978 and The Reject Shop. It is currently home to a branch of Superdrug.

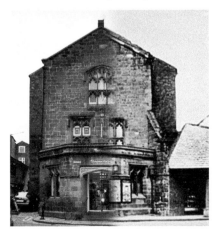

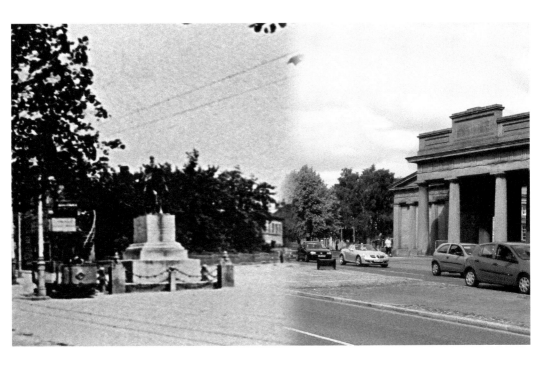

Castle Gates, 1905 and 2010

The large gateway with its massive Doric columns forms the entrance to Chester Castle. It was designed by the architect Thomas Harrison and building works were carried out from 1788 to 1822. The castle itself was built in 1070 by Hugh Lupus, the 1st Earl of Chester, and the Chester Crown Court is now housed here. Also to be found within the courtyard is the Cheshire Military Museum, which is well worth a visit. Note the tramcar that Field Marshal Viscount Combermere once looked down on.

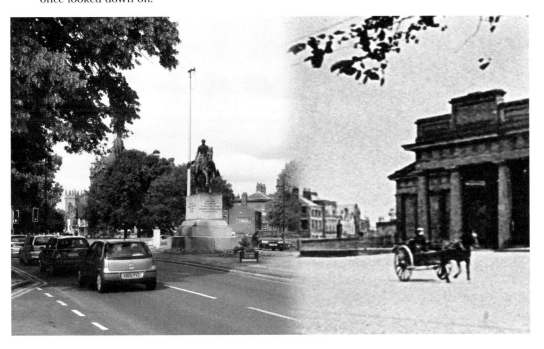

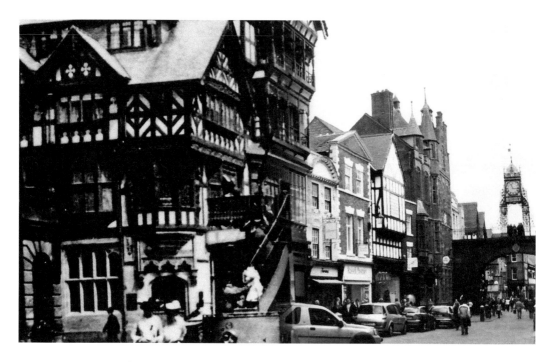

Eastgate Street Junction, St Werburgh Street, 1905 and 2020
A look down Eastgate Street at its junction with St Werburgh Street. Very little has changed here over the intervening years. The tram conductor is helping a young girl to alight as her mother follows. The corner building seen more easliy in the modern image once housed the Bank of Liverpool, later Martins Bank and eventually Barclays.

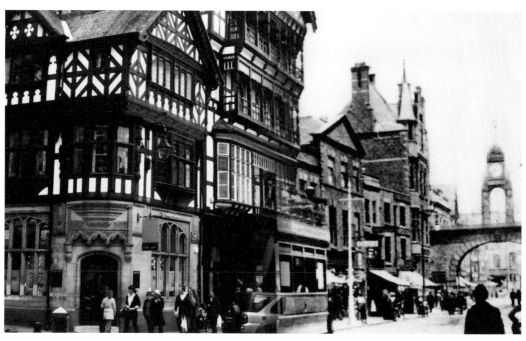

Eastgate Street, 1963 and 2010

Looking now into Eastgate Street from The Cross. As you can see, The Cross is not there in the 1963 photograph but is in the modern one. The Cross was first mentioned in the City Records in 1377. Parliamentary forces demolished it at the end of the Civil War. The base is at Plas Newydd in Llangollen, and the rest was hidden under the steps of St Peter's Church where it remained until 1820. After spending time in a churchwarden's garden and the Grosvenor Museum, it was erected on its original site by Chester City Council in 1974.

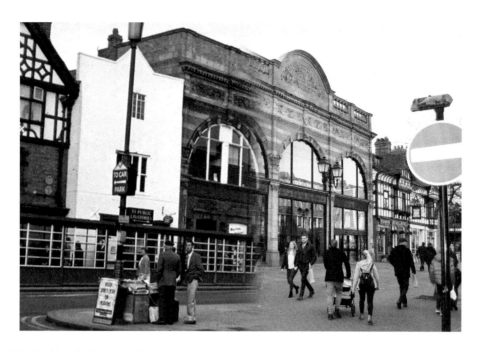

The Red-brick Coachworks

The original bus station was situated beside the attractive terracotta and red-brick Westminster Coach and Motor Car Works building with its elaborately moulded terracotta and red-brick façade. This most attractive of buildings had been built in 1913 to a design by Philip Lockwood to house a coach-building workshops and motor showrooms. Cars were sold from the showrooms up until the 1970s. It was rebuilt in 1981–84, retaining the original façade, to become the new home of the Chester library. Chester library has now moved to the former Chester Odeon, now the Storyhouse in Hunter Street, leaving this building to enjoy another lease of life with the same red-brick front elevation.

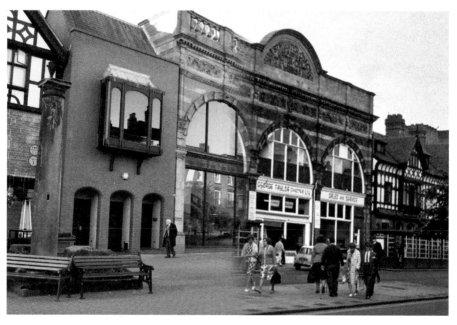

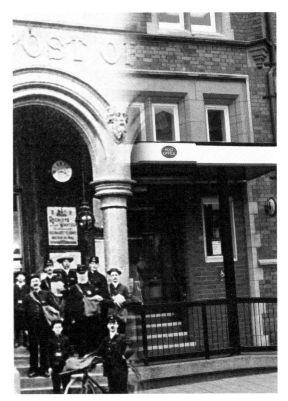

St John Street, 1905 and 2010
The General Post Office in St John Street
has been in the same building for many
years, and the old photograph shows it
in its original glory in 1905. The modern
photograph shows the changes that
have been made over the years. I doubt
as many postmen and telegraph boys
work from there now? At the time of
writing the post office in St John Street
is threatened with closure.

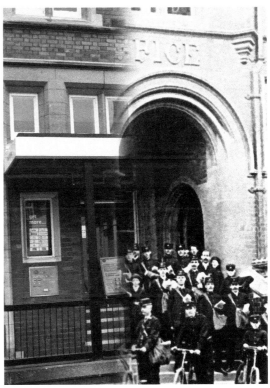

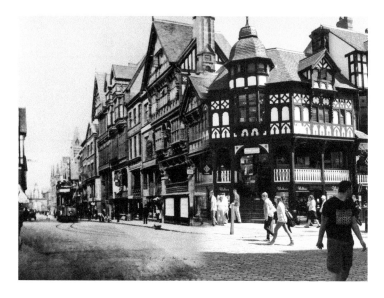

The Cross

At the end of Upper Watergate Street we find Chester's most famous antiquity, the Chester Cross. The Cross is at the junction of Northgate Street, Eastgate Street, Watergate Street and Bridge Street. This was the centre of the city for hundreds of years. It was also the location of the Roman Principia, which would actually have been found where the church of St Peter now is. The roads were set out in this fashion by the Romans, each road leading away from The Cross in the city centre. This medieval cross was destroyed like others during the Civil War in the name of iconoclasm, when religious artefacts were summarily smashed and carried off. The only truly original piece is the top of the shaft, which once contained small statues in the niches. It was not until 1804 that some pieces of The Cross were recovered from beneath the church steps and given to Sir John Cotgreave for use in the garden of his new house 'Netherleigh' at Handbridge, but eventually, they were returned to the city. The head of The Cross went to the Grosvenor Museum and eventually, The Cross with new additions, was re-erected elsewhere, eventually returning in the 1970s from whence it came. This area has always been of great importance to Chester.

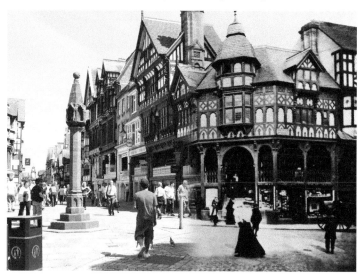

Foregate Street, 1920s and 2010

This shot of the lower end of Foregate Street shows, in the old photograph, the White Lion public house. This pub was bombed during the Second World War and the modern extension built in place of the black and white building that stood there before. Other than the rebuilding of the bombed wing and the change of use, little has altered in the old and new photograph.

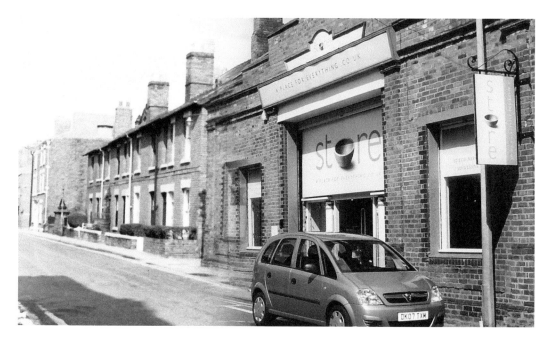

Queen Street, 1970 and 2009

Queen Street is in the centre of the city at the rear of Foregate Street. In the old photograph we can see Weddel & Co., which was the cold storage depot for the meat from the abattoir across the road. This abattoir has now gone to make way for the Boots store.

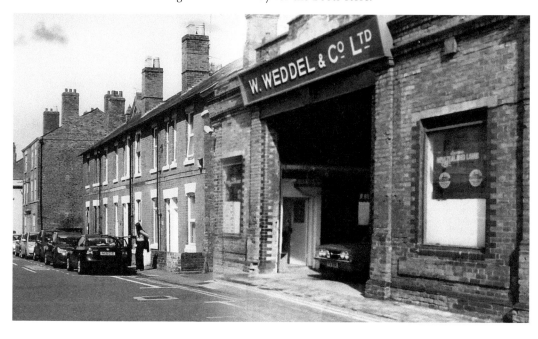

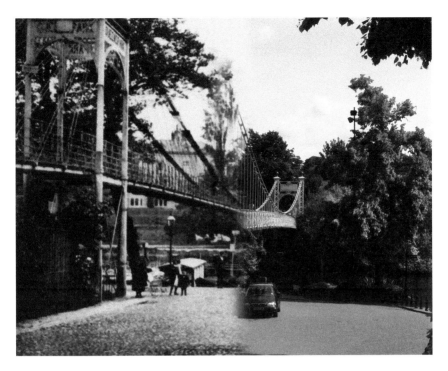

The Chester Suspension Bridge, 1920 and 2010
Another look at this famous Chester landmark that is the route for pedestrians from the Groves to the affluent Queens Park area on the other side of the river. Two years after the old photograph was taken it would be demolished and the new one erected. This, in turn, was restored in 1998.

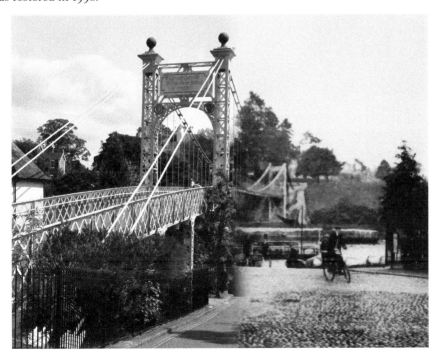

Bridge Street, 1875 and 2009

The buildings above Row level in the centre are mid-seventeenth century. St Peter's Church is at the top, and little has been altered over the years other than cosmetically. Most of the alterations and remodelling of the city were the work of John Douglas. This may not be the best of old photographs showing horse-drawn cabs in the centre of the road awaiting custom, but with the date of 1875, does it really matter?

Eastgate Street, 1800s and 2010
A similar image now to the last but a much older one; it is illustrating just how little has changed over the years from the 1800s to the modern day. The old photograph is quite poor but filled with period interest; the tea delivery van is turning into Northgate Street, a veritable snapshot in time.

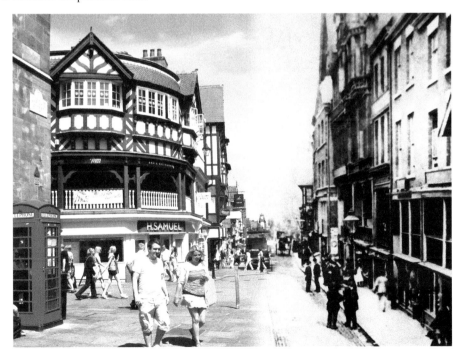

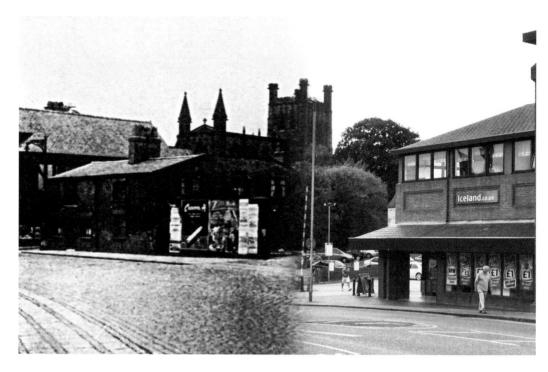

Frodsham Street from Cow Lane Bridge, 1950s and 2010

The name Cow Lane no longer exists in Chester, but this road, now known as Frodsham Street, was once paved with granite sets and was named as it led to the former cattle market at Gorse Stacks. The bridge that crosses the canal here is still called Cow Lane Bridge and bears a plaque to commemorate its opening by Alderman EW Keys on 26 January 1960 after its reconstruction.

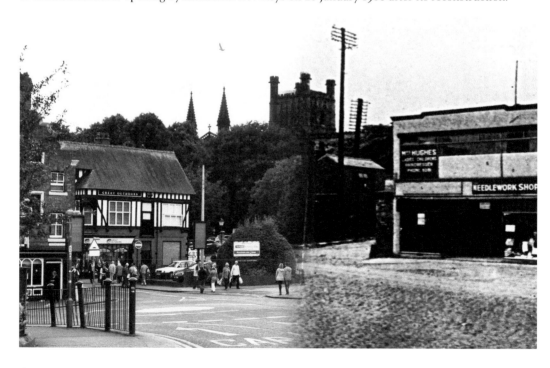

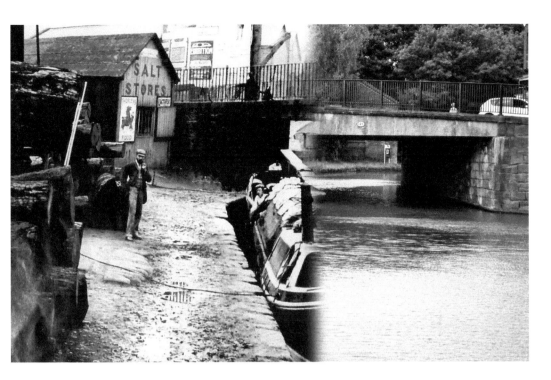

Cow Lane Bridge, 1910 and 2010

During the intervening years, canal travel has given way to road and rail, but in this old photograph, we can see canal barges at the wharves that were either side of Cow Lane Bridge. On the right, partly hidden by the bridge, is a wide-bodied canal barge that could only trade between Chester and Ellesmere Port. The main Shropshire Union canal in the opposite direction was of the narrow variety.

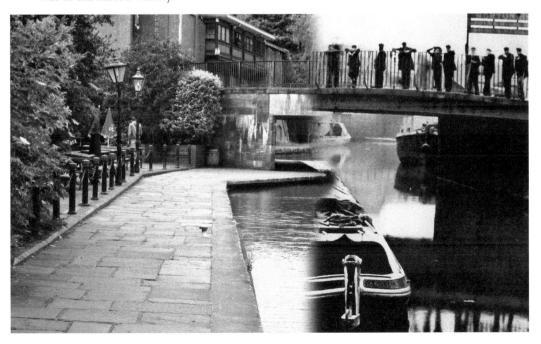

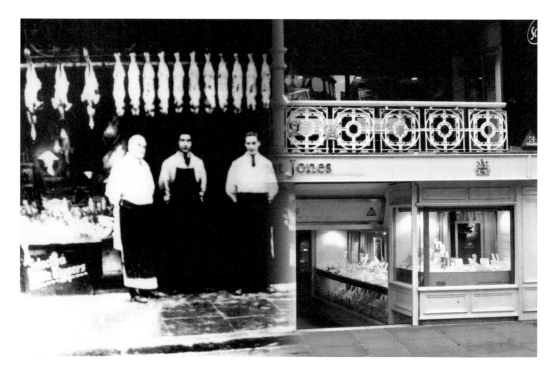

Eastgate Street Shop, 1930s and 2010
This shop is a good example of one of the flower shops on the Eastgate Street Row. It is situated at No. 10 Eastgate Street and in the 1930s housed TL Wilkinson & Sons Ltd (Muirhead & Willcock Ltd), fishmongers and butchers. The old picture is not of the best quality but the roundels in the railing on the second row can be seen.

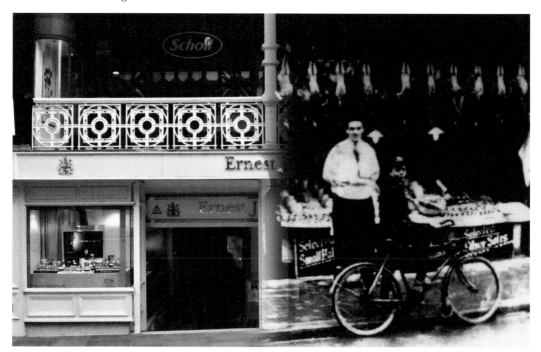

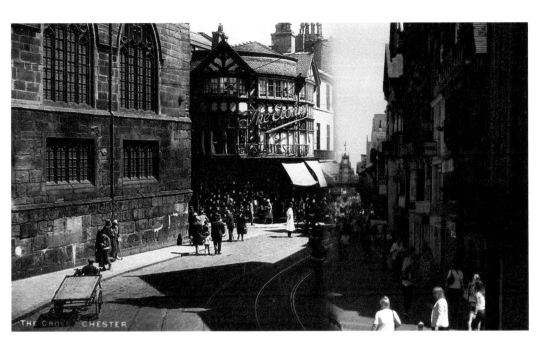

The Chester Cross

At the intersection of the former Roman roads in the city centre is Chester Cross or the Chester High Cross. It is a Grade II listed building dating from the fourteenth century, and it was replaced with a new one in 1476 and then gilded in 1603. Like similar crosses elsewhere in the county it was damaged by the Parliamentarians in the Civil War and the parts spread around the county.

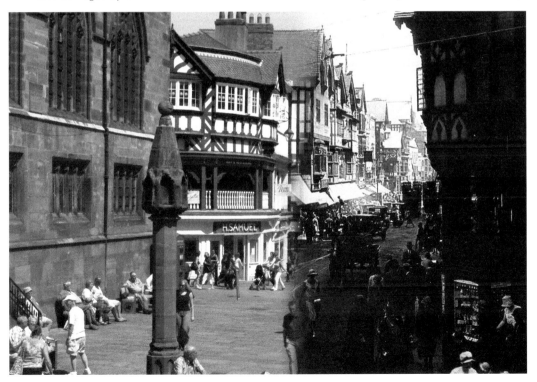

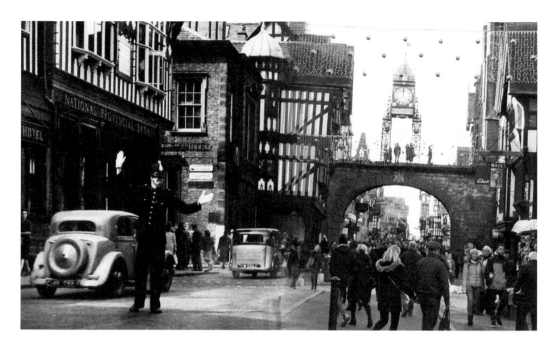

Eastgate Street Policeman Directing Traffic

A familiar location, albeit the other side of the gate, this time in the 1950s when a policeman standing in Foregate Street controls the traffic coming and going from St John Street and Frodsham Street. This image shows another eclectic group of vehicles including the Rover alongside the policeman and the old bus coming through the Eastgate.

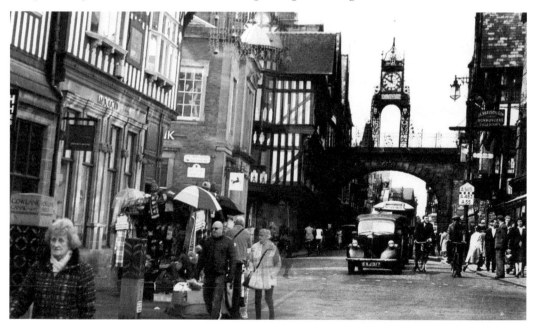

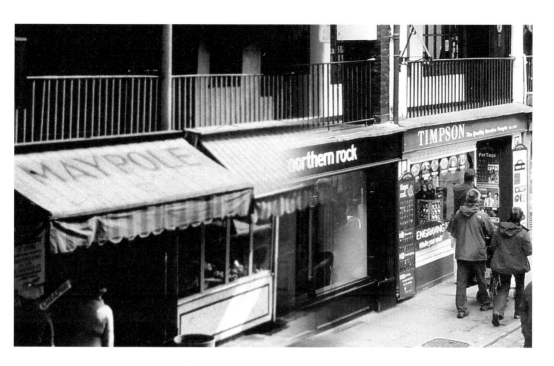

Watergate Street, 1953 and 2009

These shops situated near to The Cross show the Chester Rows quite clearly with upper and lower shops. Chester is the only city in the world with such a configuration. The Victoria pub can be seen in the modern shot, above Northern Rock, and in the 1953 photograph, the Maypole grocers are there. This was part of a chain of grocers known as the Maypole Dairy Co., and the first shop in the chain was opened in 1887 in Wolverhampton.

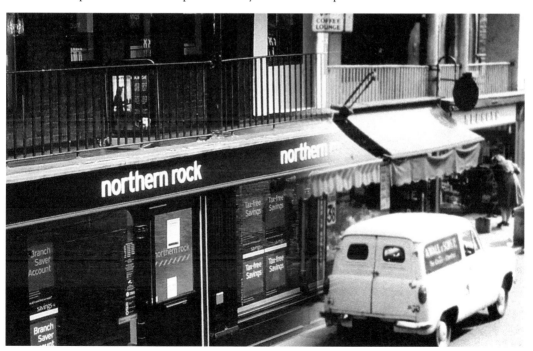

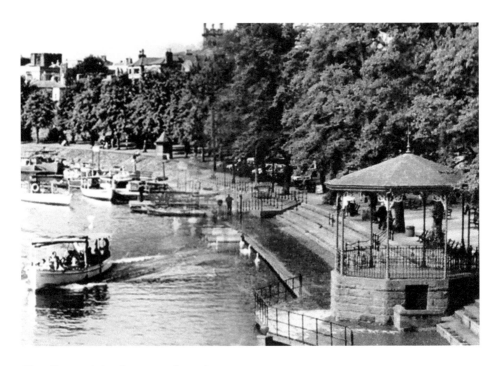

River Dee and the Groves, 1960 and 2009

This area was once extremely popular with many boat trips on the river starting from this location. It's still popular with tourists, but as the later photograph shows, traffic on the river has decreased, albeit that the pleasure boats have become larger! The swan population also seems to have decreased, but the bandstand still waits for the musicians to climb aboard and entertain the visitors.

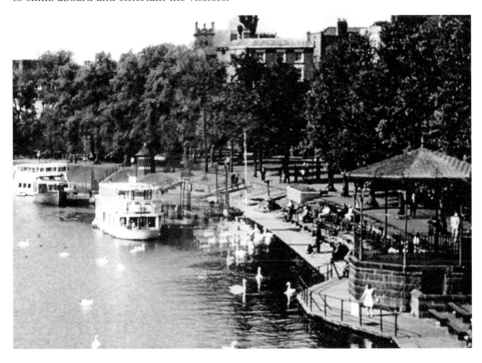

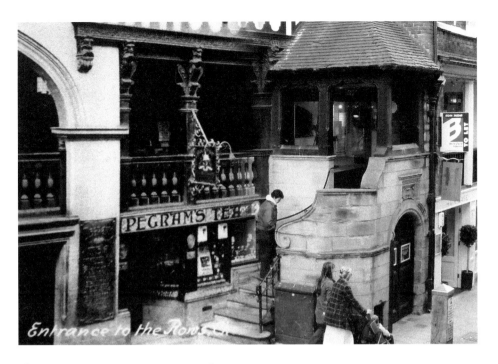

Entrance to the Rows

Shops in Watergate Street, 1912 and 2009

Back now to Watergate Street and near to The Cross, we find this set of steps leading up to the rows. This corner section was designed by Thomas Lockwood and built in 1892. Over the years, many different types of shops have come and gone. Pegrams was a well-known grocery chain with shops throughout the country and on the far right in the old photograph is No. 5, Bradshaw's Tripe Shop, selling a delicacy that we do not enjoy quite as much today!

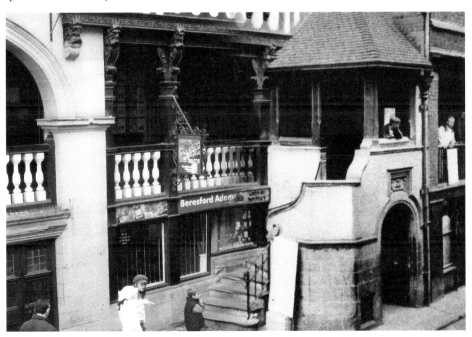

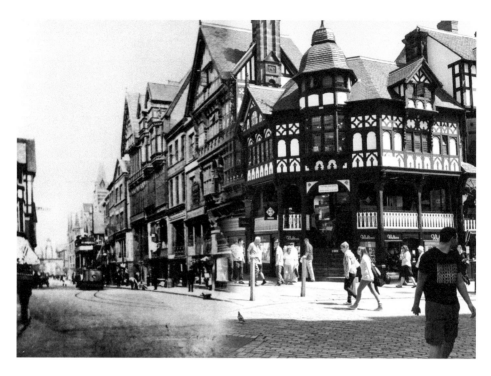

The Cross from Watergate Street, 1905 and 2010

What photograph of Chester is more iconic than of this building that stands on the corner of Bridge Street? It is one of the most famous buildings in Chester and was, in 1888, designed by Thomas Lockwood. The electric tram in the old photograph has taken over the duties of horse-drawn transport, and this one is wending its way to Saltney.

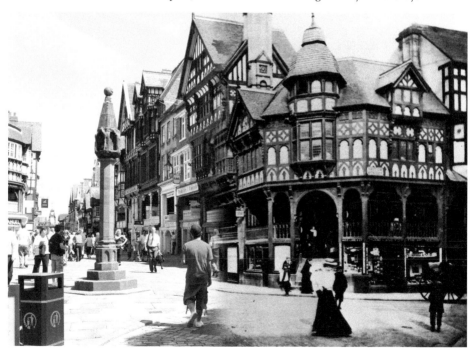

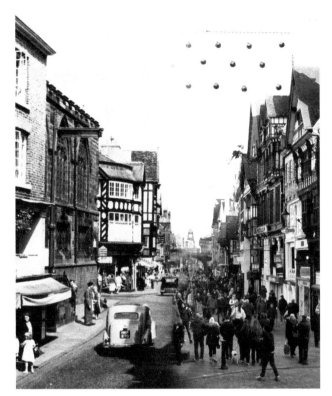

The Cross and Eastgate Street
Looking down now at a modern photograph of the Chester Cross area and past it into Eastgate Street, then onwards to the Chester Clock. The modern photo is from 2020 and the old one from 1959, at which time the roads were open to traffic and very busy. Later this whole area would be pedestrianised, with no place for double-decker Chester Corporation buses.

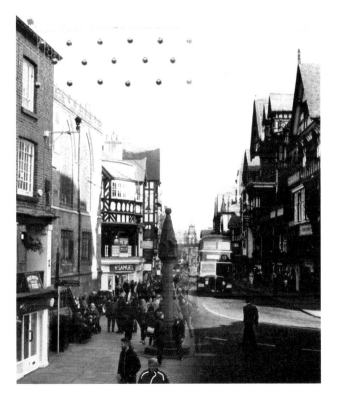

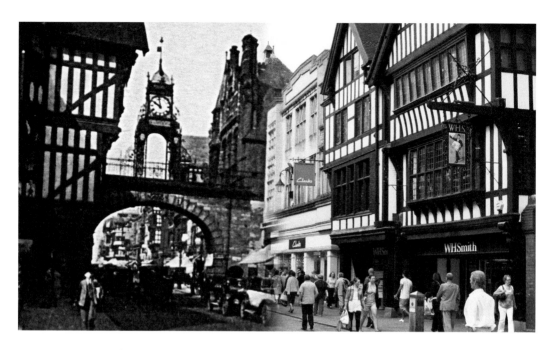

Foregate Street to the Eastgate

Another look now at the other side of the Eastgate from Foregate Street and at the junction with Frodsham Street and St John Street, a road that leads down to the ancient amphitheatre, the ancient St John's Church (at one time Chester's cathedral) and the River Dee.

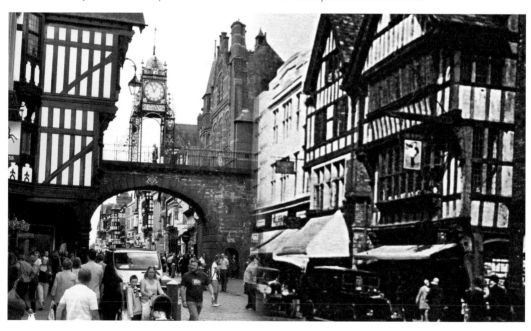

Cuppin Street, 1982 and 2008

Cuppin Street is accessed from Grosvenor Street and once went through to Nicholas Street, which can be seen at the end of the old photograph. During the building of the ring road, it was sealed off and became a car park. Part of this was the site of St Martin's Church and graveyard.

Site of Milton Brothers Garage, Union Street, 2006 and 2010

Milton Brothers garage for car repairs, sales, etc. also provided public address systems for fetes and gymkhanas. The building has been replaced with what we see in the modern photo, taken at the time of building. This is a block of one- and two-bedroom apartments called 16 Forest Court, Union Street.

Little Abbey Gateway, 1920s and 2010

This gate arch and part of the precinct wall are to the former Abbey of St Werburgh (now Cathedral Church of Christ and the Blessed Virgin Mary). This ancient gateway leads from Northgate Street to Abbey Square. It was once lined with business premises but now houses a car park and the outline of the buildings shown in the old photograph can be seen.

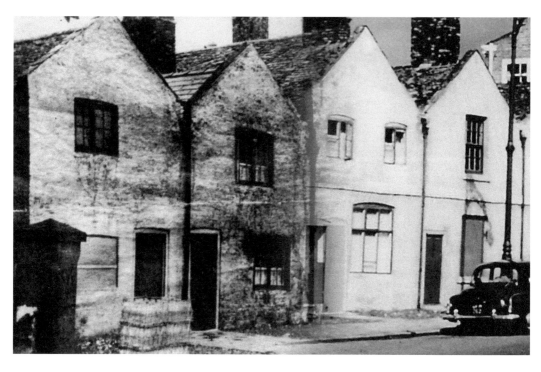

Nicholas Street
A row of buildings that in the early 1950s were semi-derelict but in the later shot have been brought up to date.

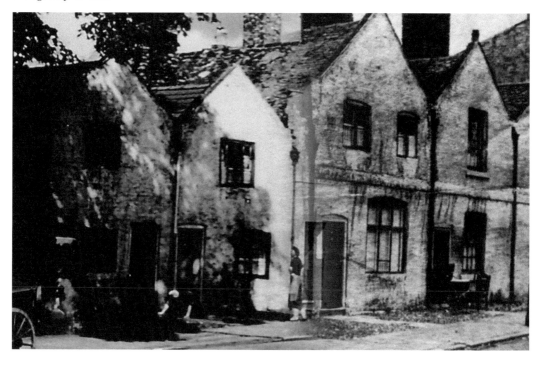

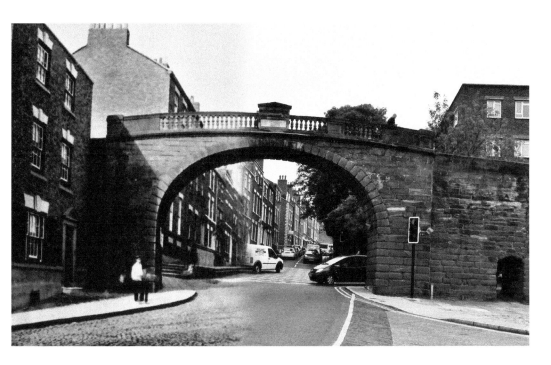

Watergate, 1902 and 2010

The Watergate, designed by Joseph Turner, was built in 1788 to replace a medieval archway which, in its heyday, was the main route from the city to the port of Chester. All the products from the ships in Chester port were taken through this gate to be recorded at the customs house further up. At that time, the present Roodee, which is at the rear of the camera, was underwater and formed part of the port of Chester. Later it silted up and has for many years been Chester's racecourse.

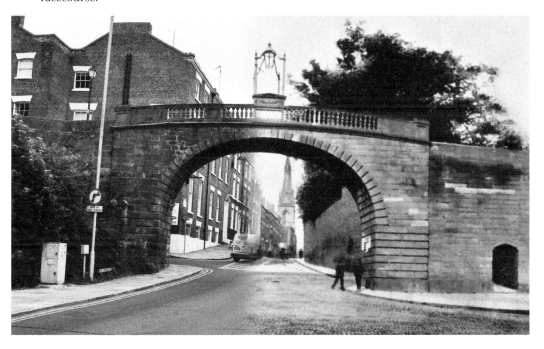

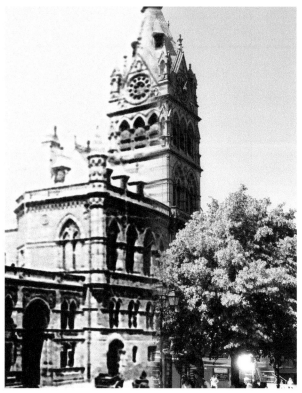

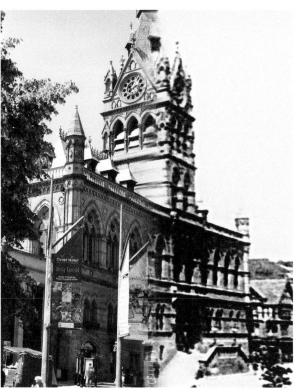

Chester Town Hall, 1914
The most prominent building
in the city centre apart from the
cathedral is the town hall, which
was opened in 1869. It was built in
Gothic Revival style with a tower
and a short spire. In 1698 a market
hall was built to accommodate
the city's administrators, but
this building burnt down in
1862. A competition was held
to build a new town hall, and
this was won by a gentleman
named William Henry Lynn of
Belfast. The building cost £40,000,
and it was officially opened on
15 October 1869 by the Prince of
Wales, the future King Edward
VII, who was accompanied by
Prime Minister William Ewart
Gladstone. On 27 March 1897, fire
gutted the council chamber on the
second floor, and the following
year this was restored by Thomas
Lockwood. The building sits
in Northgate Street and once
had the prestigious market hall
adjoining it.

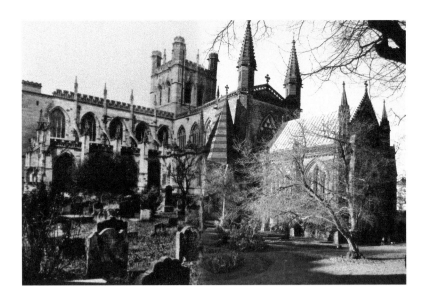

Chester Cathedral, 1902 and 2020

All the gravestones have been removed, as can be seen by comparing the two photographs. The whole area has been transformed into a garden of remembrance for the Cheshire Regiment, now the Mercian Regiment. In the foreground are the flower beds that are laid out as a tribute to the regiment in the shape of a medal and its ribbon – in summer, when the flowers bloom, the shape of the medal is more obvious. Since 1541 the cathedral, dedicated to Christ and the Blessed Virgin Mary, has been the seat of the Bishop of Chester. The cathedral is a Grade I listed building and part of a heritage site that also includes the former monastic buildings to the north, which are also listed Grade I. Much of the interior is in the Norman style and is the best example of eleventh- and twelfth-century church architecture in Cheshire. The cathedral has been modified many times from 1093 through to the sixteenth century, although the site itself may have been used for Christian worship since Roman times. All the major styles of English medieval architecture, from Norman to Perpendicular, are represented in the present building. In addition to holding services for Christian worship, the cathedral is used as a venue for concerts and exhibitions.

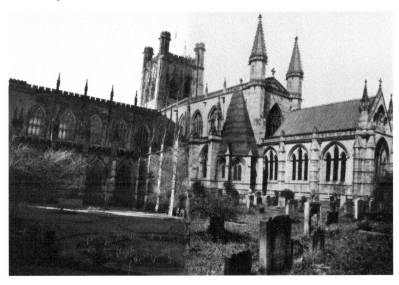

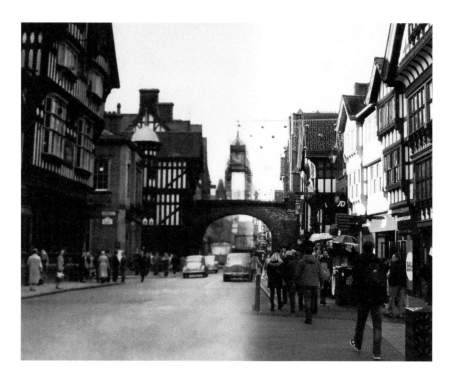

Eastgate Street with the Clock in the Distance
This famous street is in the centre of Chester and is home to the five-star Chester Grosvenor Hotel, the department store Browns of Chester and the fifteenth-century Olde Boot Inn – the oldest pub. Here the 1960s and 2020 come together.

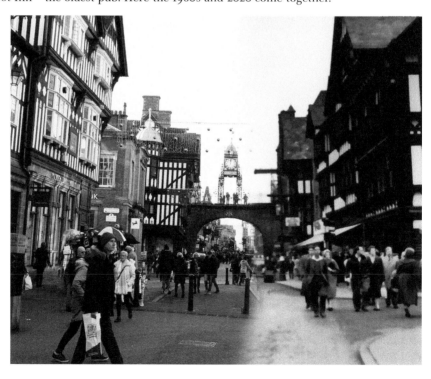

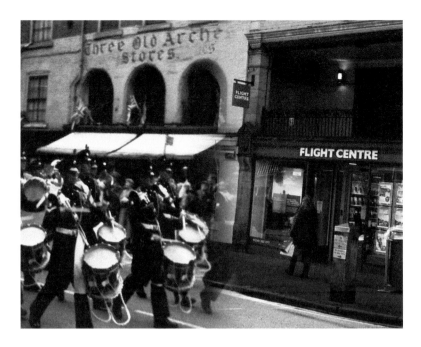

Cheshire Regiment, 1958

The army has always had a close connection with the city. The castle was the home of the Cheshire Regiment from 1881, and it remained there until 1940 when a depot was established at the Dale Barracks on the edge of the city. In the 1950s, the Cheshire Regimental Headquarters was moved back to the castle, where they remained until amalgamation into the Mercian Regiment in 2007. The photograph shows a march through the city in 1958. In the background are the ancient Three Old Arches dating from 1274. It is believed to be the oldest shop frontage in Britain.

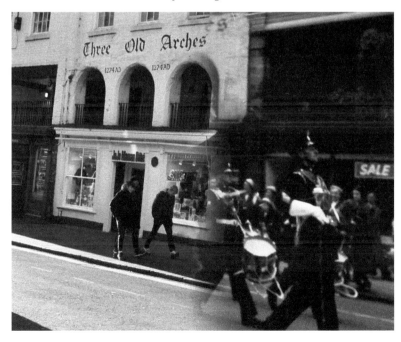

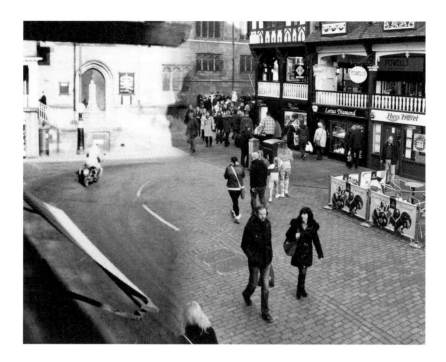

Bridge Street towards The Cross

Here we take a look from Bridge Street Rows towards The Cross. There is no Cross in the older part of the image, and the road is open to the public, as seen by the 1950s car turning into Bridge Street. A motorcycle going the opposite way passes what will be in around twenty years the location of the Chester Cross.

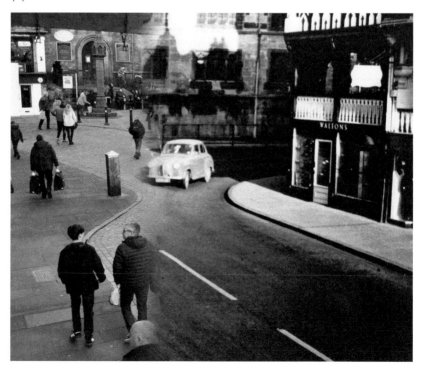

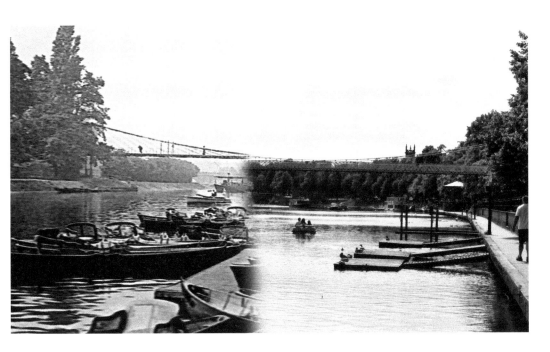

The Groves, 1910 and 2010
One hundred years separate both sides of these two photographs, and the change is plain to see. Most of the pontoons holding the many small craft have gone, but it is somewhat deceptive as quite a lot of pleasure activity takes place at this spot. In the distance is the tower of St Mary's on the Hill Church. Nearer to the camera is the Queen's Park Footbridge.

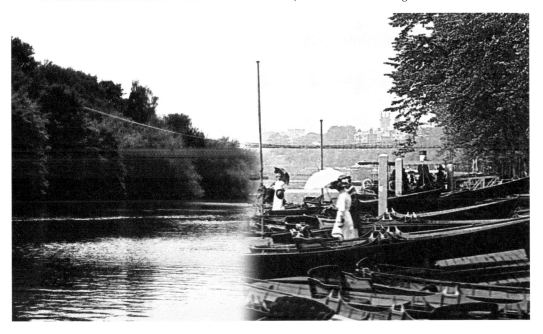

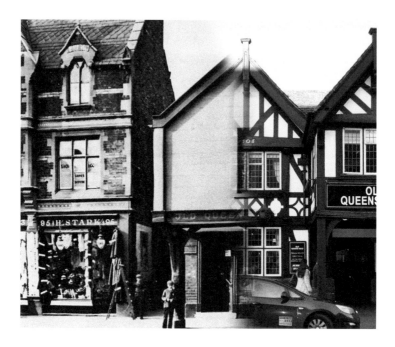

Ye Olde Queens Head, *c.* **Early 1900s and 2020**

Here we see the Queens Head before and after a rebuild. The pub in the modern photograph looks far different from the pub shown in the old photograph, taken before the 1939 rebuild when the pub gained its black and white mock-Tudor front elevation. The date of the original façade is recorded on the front, showing as 1506, although this could be 1508 as there is a strange squiggle on the number '6'. Then on the other side the date of rebuilding, 1939, is shown. This pub has been tastefully renovated, leaving much in the way of ancient dark wood.

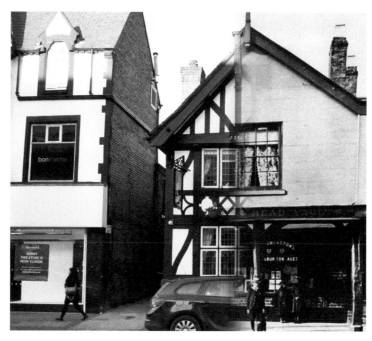

Former Cheshire Police HQ, 1965 and 2020

At the junction with Foregate Street and Grosvenor Park Road we see the red-brick building that was formerly the Cheshire Police Headquarters. The black and white building next to it was demolished to make way for the subway. The headquarters moved to the custom-built HQ opposite the castle. This building has now been demolished, and the police headquarters moved to Winsford.

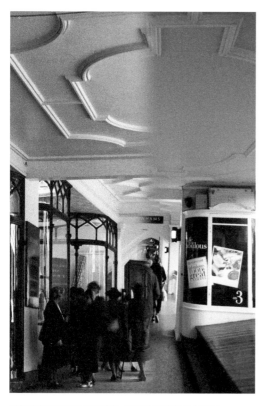

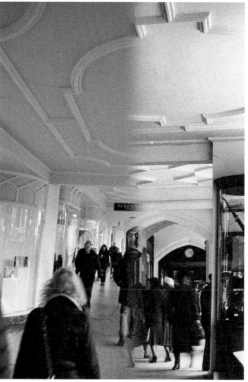

Browns of Chester

Here we see The Rows on Eastgate Street in July 1953 as they pass Browns of Chester. This was the city's premier department store, which had a staff of over 600. The department store, known as the 'Harrods of the North', is still trading today. It was established in 1780 by Susannah Brown, and the store has traded from its current site since 1791. The building interior contains many ornate features such as domed glass roofs and elaborate plasterwork surrounding small chandeliers in the main entrance area. Crypt Chambers is built on the site of a house whose undercroft is still present.

Dickson's Seed Warehouse, St John Street, 1930s and 2009

This company originally traded in Eastgate Street opposite the Grosvenor Hotel. The building then went on to be an early cinema, Woolworths and now a branch of Next. They also had a nursery in Dickson's Drive, Newton, but their main warehouse was this one situated nearby in St John Street. It is directly opposite the amphitheatre and St John's Church. It later became SG Mason Ltd, printers, and has now been completely modernised and contains offices, etc.

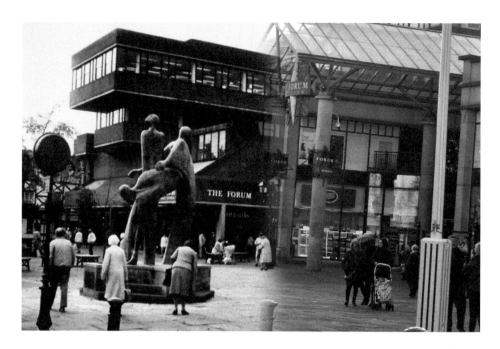

The Forum Shopping Centre, 1993 and 2020

Now the Forum Shopping Centre in Northgate Street, an old market square. The original market hall was demolished in 1967 and the old one here built to replace it. This new piece of architecture was not well received, and people mourned what it replaced, so much so that in 1995 this too was demolished. Some perhaps are still not sure that the modern building should face the front of the ancient Chester Cathedral as it does, but everyone to their own taste... The old market hall was not the most attractive but had antiquity on its side.

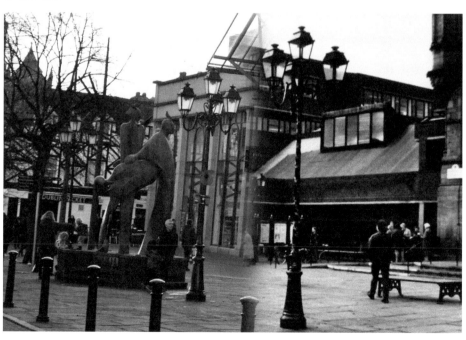

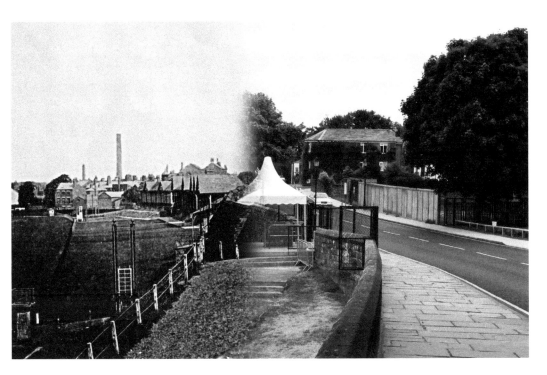

The Roodee and Walls, 1950s

This photograph is a view down Nun's Road towards Watergate and looks across into the Chester racecourse, known as the Roodee. The old picture shows the grandstand that burnt down on 28 September 1985. The gasworks chimneys can be seen in the distance in the old photo.

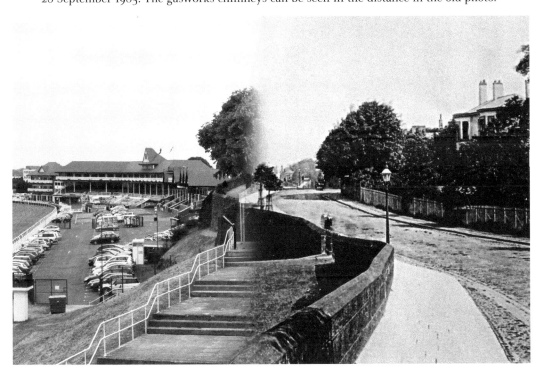

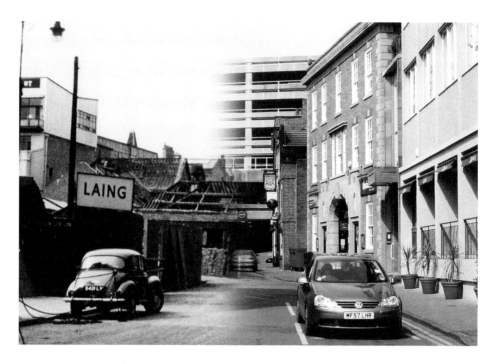

Newgate Street, 1964

It is 1964 and demolition has started. This much-altered street in the middle of the city used to lead from Pepper Street into Eastgate Street. It has now become the entrance to the car park for the shops and the Grosvenor Hotel. The large and prestigious building with its impressive portico on the right has thankfully been retained – hence we have a feature that ties the two photographs together.

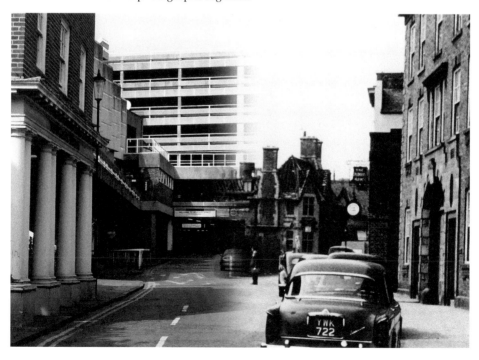

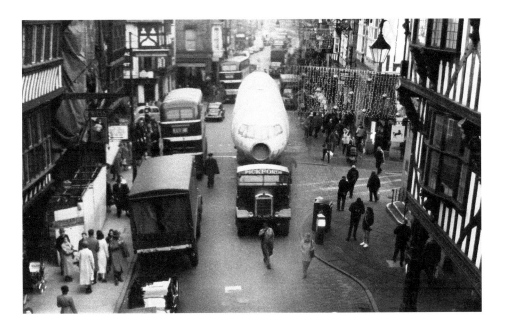

Comet Airliner Travels to Chester by Road

It became necessary to convey two of the Comet Mk 2 aircraft from Short & Harland Ltd in Belfast to de Havilland's Broughton site, the journey taking from Saturday 22 October to Tuesday 1 November 1955. The de Havilland Comet was a beautiful aircraft, but after a few crashes it needed a thorough check over. It was concluded that having square-shaped windows was a likely cause of trouble, so these were replaced with what are now standard oval or round windows. As for the journey, this was before motorways and the A55, so, accordingly, this huge aircraft had to be towed on a basic trailer through the streets of Manchester, Stockport and Chester on its journey from Preston Docks. It is seen travelling towards the Eastgate and onwards down Bridge Street.

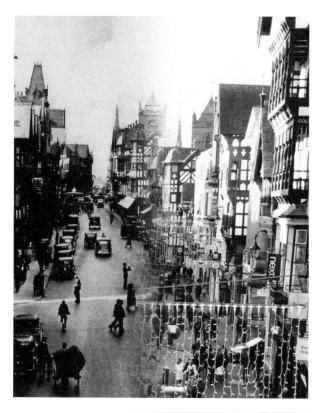

Eastgate, 1955 and 2020
These photographs were taken
from the walls near to the
Eastgate clock, as we look down
into Eastgate Street towards the
Chester Cross. A police officer
can be seen on point duty at the
junction with St Werburgh Street.
It looks a thankless task with
a myriad of motor traffic and
pedestrians seemingly wandering
about at will!

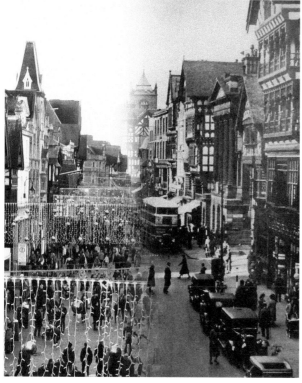

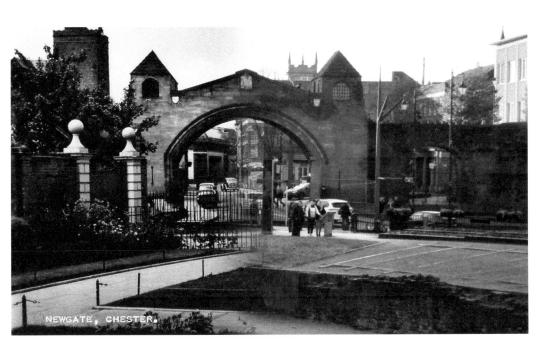

NEWGATE, CHESTER.

Newgate, *c.* 1950s and 2020

We are now looking across the exposed section of the amphitheatre to the large and impressive gate called Newgate. When the walls were breached to allow traffic to flow more freely in 1938, this most recently built gate in the walls was constructed. Again the walkway is raised to pass over the bridge, and this leaves us with an excellent vantage point at the top to view the amphitheatre. The bridge was built in red sandstone and was designed by Sir Walter Tapper and his son Michael. Unlike quite a few modern buildings in Chester, it was generally well received by historians and the general public alike. As we view the gate from the Little St John Street end, we can see that only half of the amphitheatre is exposed; the other half is still covered.

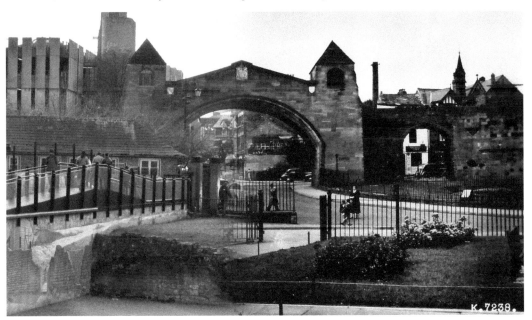

K.7238.

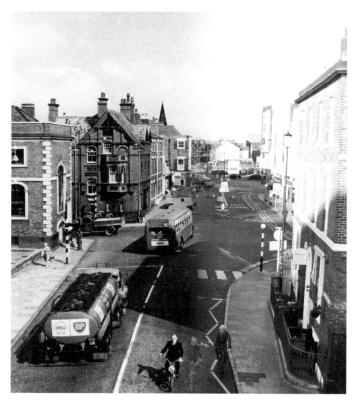

Old Northgate Street from the Northgate, 1958
Taken from the top of the Northgate at the traffic thundering below as it heads for the Fountains Roundabout. Just out of sight on the left is Chester Canal with the Bridge of Sighs crossing it to take felons from what was the Chester Gaol part of the Northgate to the chapel in the Bluecoat school. The gate stands on the site of the original northern Roman gateway to Chester and was once a narrow and unimportant gateway for local access. During the medieval period, it was rebuilt and consisted of a simple rectangular tower, but this was later greatly expanded and also became the site of the local gaol where prisoners were kept in the most basic of accommodation to await their fate. Then in 1810, Thomas Harrison added the rebuilding of the gate to his many projects in the city.

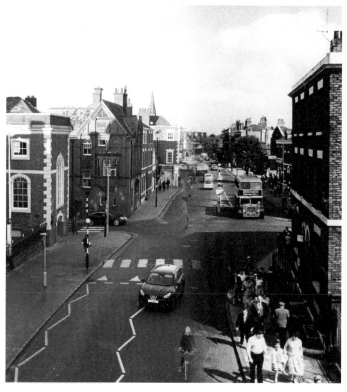

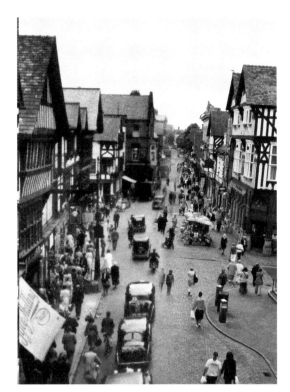

Eastgate into Foregate Street, 1958
We are looking down from the Eastgate Street clock that stands proudly above the Chester walls that cross the busy street below. The view is towards the water tower. In the far distance we can see that only a few changes have been made to the vista, at least from this vantage point. The 1958 image shows an eclectic mix of cars that today would be considered classics.

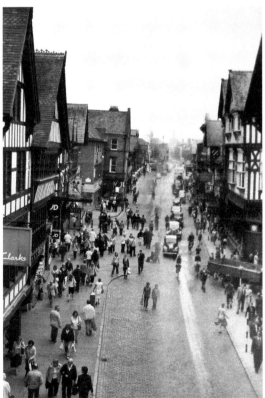

Acknowledgements

Thanks to all who have allowed me to use photos from their archives of postcards and photographs over the years. To the photographers of old, who left us their snapshots in time of a Chester that is long gone. And of course, as usual, my wife Rose, for her patience during the writing of this book.

Also by the Author

A–Z of Crewe
Britain Invaded (fiction)
Cheshire Through Time
Chester in the 1950s
Chester in the 1960s
Chester Pubs (with Len Morgan)
Chester Through Time (with Len Morgan)
Frodsham and Helsby Through Time
Knutsford History Tour
Knutsford Through Time
Macclesfield History Tour
Macclesfield Through Time
Middlewich (with Brian Curzon)
Middlewich & Holmes Chapel Through Time
Nantwich History Tour
Nantwich Through Time
Northwich History Tour
Northwich Through the Ages
Northwich Through Time
Northwich Winsford & Middlewich Through Time
Remembering Steam (with Phil Braithwaite)
Sandbach, Wheelock & District Through Time
Steam Nostalgia in the North of England (with Phil Braithwaite)
The Changing Railways of Britain (with Phil Braithwaite)
Villages of Mid Cheshire Through Time
Winsford Through Time